Hopi Kachina Dolls

Hopi Kachina Dolls

with a Key to their Identification

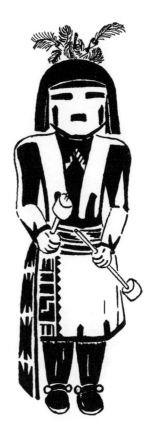

BY HAROLD S. COLTON

Color Photographs
by Jack Breed

University of New Mexico Press, Albuquerque

Revised edition 1959; fifth printing, 1973
Library of Congress Catalog Card No. 59-5480

Composed, Printed, and Bound at
University of New Mexico Printing Plant
Albuquerque, New Mexico, U.S.A.

To my wife

Foreword

THIS LITTLE VOLUME tells how to identify Hopi kachina dolls, whose multiplicity has confused their collectors for years. It is based upon a list prepared by Edmund Nequatewa, of Second Mesa. The list was enlarged by Jim Kewanwytewa, of Oraibi, whose keen eye for details has enabled me to fill out the descriptions of masks and costumes, and to add many new dolls to the original list. The combined list was further elaborated and extended by comparing it with those of Fewkes (1894 and 1903), Dorsey and Voth (1901), Voth (1901), Stephen (1936), Earle and Kennard (1938), and Zuñi lists of Stevenson (1887) and Bunzel (1932). I am deeply indebted to those Hopi men, without whose assistance the book could not have been written; to Dr. Edward Kennard, who advised on the spelling of Hopi names; to Katharine Bartlett, who has had the tedious job of translating my bad handwriting, spelling, and punctuation into a legible manuscript; to Helen Ivory who arranged the notes; and to my wife, who gave valuable advice and criticism while the work was progressing.

Because of the continued demand for *Hopi Kachina Dolls,* apparently stimulated by the original edition in 1949, this work has been revised. Errors have been corrected and sixteen additional kachinas added. For their aid in this revision, I wish to thank my sister, Suzanne C. Wilson, and Carol T. Jones, as well as Barton Wright who re-drew a few of the engravings, adding new ones and correcting a few of the old ones.

HAROLD S. COLTON

Museum of Northern Arizona
Flagstaff, Arizona
January, 1959

Contents

Illustrations

1. What Is a Kachina?

EVER SINCE J. Walter Fewkes, of the Smithsonian Institution, wrote his first illustrated report on Hopi kachinas, in 1894, a growing number of people have become interested in the Hopi Indians and their delightful carved and painted kachina dolls. For years collectors have treasured these small representations of Hopi supernatural beings without being able to learn much about them, and it is for those who wish to identify their dolls that this book has been planned. Since many people do not know about either kachinas or kachina dolls, we will diverge a little to explain what they are before showing how to identify the dolls.

In the northern parts of the states of New Mexico and Arizona are a number of compact Indian villages with flat-roofed houses built of stone or adobe. Because these Indians lived in villages, the Spanish word for which is *pueblo,* they are called Pueblo Indians. They are known to be descendants of the prehistoric people who lived in northern Arizona and New Mexico fifteen hundred years ago. Since that time they have developed a rich culture which, in certain aspects, because of their innate conservatism, has withstood the white

man's efforts to supplant it with his own. Although most of the Pueblo Indians live in the Rio Grande Valley, near Albuquerque and Santa Fe, a chain of villages extends to the westward across the high plateaus and ends with the Hopi Indians who live on three mesas in northeastern Arizona.

Many of these Pueblo Indians, particularly the Hopi and Zuñi, have ceremonies in which masked men, called kachinas, play an important role, and it is of these masked characters of the Hopi that we are going to speak.

And so you will say, "Ah, yes, a kachina is a masked character, but who is he, what is he, and what is his significance?" A Hopi Indian will tell you that a kachina is a supernatural being who is impersonated by a man wearing a mask, and he will add that the kachinas live on the San Francisco Peaks, near Flagstaff, Arizona, and on other high mountains.

A kachina has three aspects: the supernatural being, as he exists in the minds of the Hopis; the masked impersonator of the supernatural being, who appears in the kivas and plazas; and the small dolls carved in the same likeness. The first two aspects are termed kachinas and the latter, kachina dolls. Since kachina dolls, with which we are primarily concerned, depend for their significance upon the masked impersonations, we must consider kachinas first.

The yearly calendar of Hopi religious ceremonies is divided into two parts, from winter solstice to mid-July marking the first half, and from mid-July to winter solstice the second half. The first half, which extends perhaps a month past the summer solstice, is marked by kachina ceremonies. A group of about thirty "official" kachinas, called Mong Kachinas, takes part in five major ceremonies held during this period: Soyalang-eu (Winter Solstice Ceremony) in December, Pamuya in January, when the sun appears to move north again, Powamuya (Bean Ceremony or Bean Dance) in February, Palölökonti (Water Serpent Ceremony)

in February or March, and the Niman Kachina (Home Dance Ceremony) in July, when the sun appears to move south. These major ceremonies last nine days, and mostly are held in the kivas, where only the initiated may witness them. Some, like Bean Dance, Niman Kachina, etc., have parts which are witnessed by the Hopi public, either in the kivas or in the plazas.

During this first half of the Hopi year, there are also held one-day ceremonies, called ordinary or regular kachina dances, in which the kachinas dance in the village plazas. In these ceremonies a group of twenty to thirty kachinas, all identically masked and dressed, may take part, or it may be a "Mixed Kachina Dance," where each mask and costume is different. Any ceremony, whether of nine days or one day duration, is a social occasion for the village, for friends and relatives come from the neighboring towns to see the "dance" and partake of the feasts that are always prepared.

During the second half of the year from July, when the Niman Kachina takes place, until the following December, no ceremonies are held in which masked impersonators take part. There are a number of ceremonies like the famous Snake Dance but the participants do not wear masks. The Niman Kachina is called the Home Dance, because it is the last appearance of the kachinas before they return to their homes on the San Francisco Peaks.

Regular or ordinary kachina dances take two forms. In one form, which we can call the Hopi pattern, the kachina dancers, in single file, walk rapidly into the plaza and form a line on one side. Keeping time with their feet, with tortoise shell rattles fastened to their legs, and rattles in their hands, they sing one verse of the kachina song. Then the line moves to an adjacent side of the plaza, repeating the same verse of the song, and then to a third side where the verse is sung at least once more. With the completion of the song, kachinas

distribute presents to the children and retire. After a rest of one-half hour, they return to the plaza and sing a new verse, repeating the performance as before. This routine they will maintain from about noon until nearly sunset, singing about six to eight verses of the song.

In the second form of kachina dances, built on a pattern borrowed from the Rio Grande Pueblos, a chorus of old men, accompanied by a drummer, supplies the music and songs for the line of dancers, who do not sing. The dancers form a line on one side of the plaza, and progress around it in the same manner as described above.

In the intervals when the kachinas are resting, with their masks removed, somewhere below the mesa rim, clowns enter the plaza and afford comic relief to the spectators. They mimic certain spectators and act out little skits, sometimes, we must admit, not in the best taste, according to our way of thinking, which, after all, is quite different from the Hopi way.

When a Hopi man places a mask upon his head and wears the appropriate costume and body paint, he believes that he has lost his personal identity and has received the spirit of the kachina he is supposed to represent. Men, never women, take the part of male and female kachinas. As far as we can determine, the Hopis believe that, through a priest, usually an old man not in costume, the prayers of the people are given to the kachinas to carry to the gods. Therefore the kachinas play a role somewhat similar to the saints of the Christian religion, and some, like saints, are supposed to be the spirits of very good men. However, not all kachinas are good spirits; some are demons or ogres.

In addition to the kachinas, the Hopis recognize about thirty-two major supernatural beings who might be called deities. The most important of these are Sotuqnang-u, the god of the sky, sometimes called "the heavenly god"; Masao,

the god of the earth; Kwanitaqa, the one-horned god who guards the gate of the Underworld (he might be compared to St. Peter, for the Underworld is the Hopi Heaven); and Alosaka, the two-horned god of reproduction of man, animals, and plants, sometimes called "the germ god." Although a few of the deities may be impersonated as kachinas or represented by figurines, the majority are never impersonated or represented by dolls.

Hopi children believe in kachinas just as our children believe in Santa Claus. In a kachina ceremony, the children are not supposed to recognize their fathers, uncles, or parents' friends who are disguised by masks and elaborate costumes. As Santa Claus comes at a certain season, bearing gifts to the children, so certain kachinas bring to the children kachina dolls, miniature bows and arrows, sweets, fruits, and other food. Hopi children enjoy a whole series of Christmas delights during the period from late December to July.

Kachina dolls are given to the children not as toys, but as objects to be treasured and studied so that the young Hopis may become familiar with the appearance of the kachinas as part of their religious training. Prior to a kachina ceremony, the fathers and uncles of the village children are busily occupied in making dolls in the likeness of the kachinas that will take part in the ceremony. On this great day, the kachinas give to each child, standing in solemn awe, the dolls made especially for him by his relatives. The dolls are taken home, where the parents hang them up on the walls or from the rafters of the house, so that they may be constantly seen by the children of the family and their playmates. In this way Hopi children learn to know what the different kachinas look like. Thus we see that Hopi kachina dolls are neither idols to be worshipped or ikons to be prayed to, but only objects for use in the education of the child.

The Hopi recognize over two hundred kachinas and fre-

quently invent new characters. One Hopi we consulted believed that, except for the kachinas that officiate at the major ceremonies in the annual cycle of religious observances, a large number were invented in the last half of the nineteenth century. Certain kachinas are believed to be the spirits of departed Hopis. Thus the Cross-Legged Kachina is thought to be the spirit of a very kind Mishongnovi man who died about seventy years ago.

The names by which the kachinas are known may be descriptive and such names can be translated into English, as Left-Handed Kachina and Long-Haired Kachina. The Hopi name for the Crow Mother, a dour creature with wings on the side of her head like a Valkyrie, is translated "Man with a Crow Wing Tied To." Many kachinas are named for birds and mammals, like the Rooster, Eagle, Bear, and Badger Kachinas, while others take their names from the peculiar calls that the kachina utters such as Hu-Hu, Aholi, and Soyoko. Other kachinas have definite names which have no relation to their description or call and have no English equivalents. Some kachinas have been borrowed by the Hopis from other Pueblo Indians, and their original names have been retained in the Zuñi, Tewa, or Keresan language, as the case may be.

Kachinas are difficult to classify, not only because the Hopis have rather vague ideas about their appearance and function but because these ideas differ from mesa to mesa, pueblo to pueblo, and clan to clan. However, we can recognize a number of classes of kachinas even if there is not complete agreement among the Hopis. The lack of a clear system of classification is not surprising, for Hopis do not feel it necessary to pigeon-hole their information as we do. They do not think of things as members of classes of objects but as individual items.

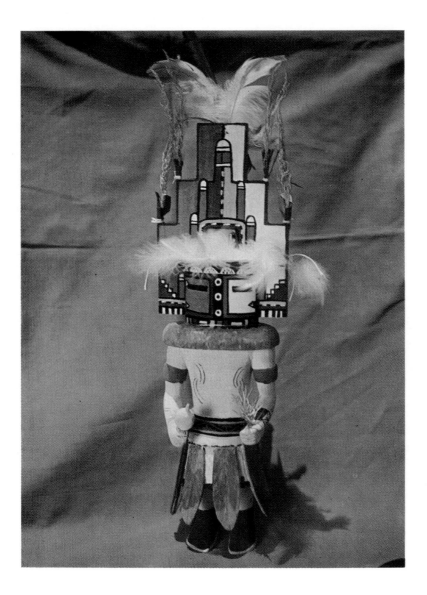

FIGURE 1

A type of headdress called a tableta. Hemis Kachina (No. 132).
See also Figure 11. *Photograph by Jack Breed.*

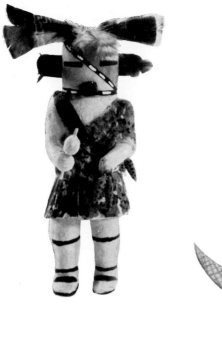
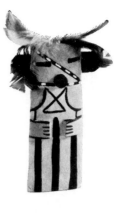
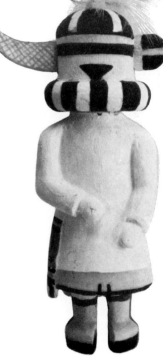

FIGURE 2

Upper. Two types of dolls representing the same kachina.
Konin or Supai Kachina (No. 143).

 Left. A doll carved from a cottonwood root.

 Right. A simplified doll carved from a flat piece
of wood—a kind given to Hopi infants.

FIGURE 3

Lower. A kachina with a single horn on the side of the head.
Zuñi Rain Priest of the North (No. 154). See also Figure 7.

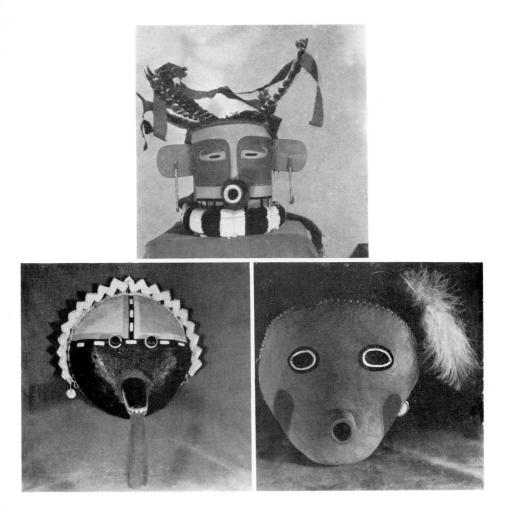

FIGURE 4

Three types of masks.

Upper. A cylindrical case- or helmet-mask, made of two pieces
of rawhide stitched together. War Kachina Leader (No. 140).
Lower left. A circular mask, made by stretching cloth over a
yucca sifter basket. Long-billed Kachina (No. 41).
Lower right. A face mask. Navajo Kachina Maiden (No. 138).

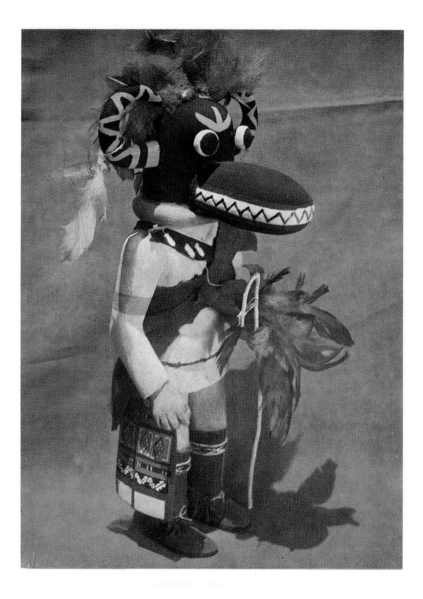

FIGURE 5

Example of a mask with a large, toothed snout. Black Ogre
Kachina (No. 29). *Photograph by Jack Breed.*

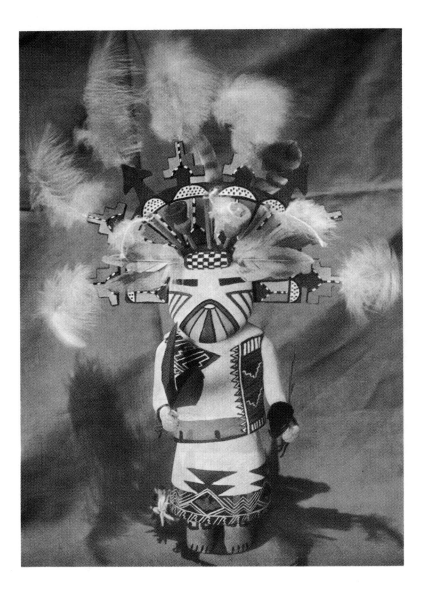

FIGURE 6

One type of female costume, consisting of an embroidered ceremonial robe fastened on one shoulder, and a kilt fastened on the other shoulder. This kachina also has an elaborate tableta. Butterfly Kachina Maiden (No. 120). See also Figures 9 and 15.

Photograph by Jack Breed.

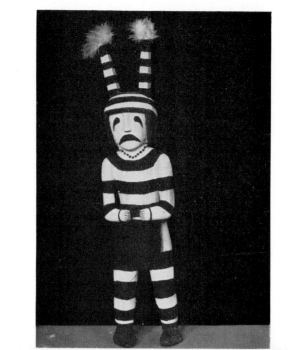

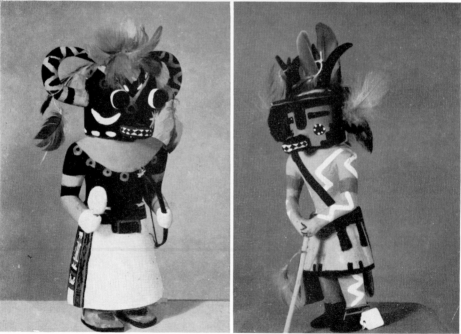

FIGURE 7. Three types of horns.
Upper. Pseudo-horns, made of soft material and attached to
the top of the mask. Hano Clown or Koshare (No. 60).
Lower left. Example of the curved horns which are attached
to the top or sides of many masks. Ho-ó-te (No. 104).
Lower right. Many masks carry real animal horns—in this case,
antelope antlers. Antelope Kachina (No. 90). See also Figure 3.

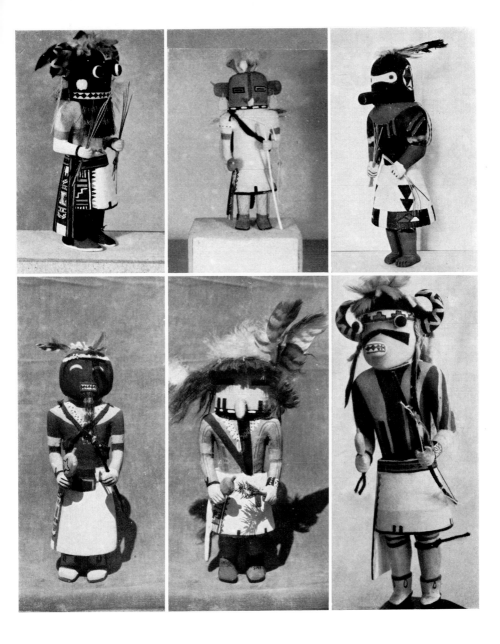

FIGURE 8

Six types of mouths. See also Figure 10.
Upper left. Horizontal mouth with a wide beard.
Tungwup Whipper Kachina (No. 14).
Upper center. Turned-up beak. Kokopölö (No. 65).
Upper right. Tube mouth. Zuñi Warrior Kachina (No. 152).
Lower left. Horizontal mouth with a narrow beard.
Chakwaina (No. 160).
Lower center. Turned-down beak. Navajo Kachina (No. 137).
Lower right. Short snout. Buffalo Kachina (No. 93).

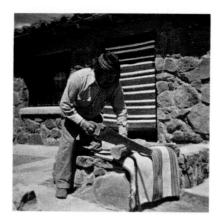
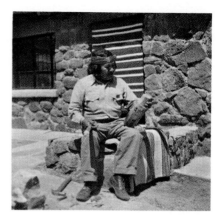
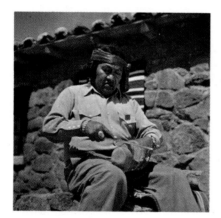
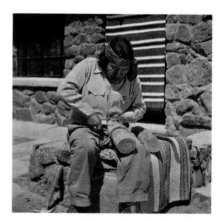

FIGURE 9

Stages in the manufacture of a kachina doll. Polik Mana or
Butterfly Kachina Maiden (No. 120). See also Figure 6.
Upper left. Jim Kewanwytewa saws a dry cottonwood root
to the length for the kachina doll he has in mind.
Upper right. He studies the root before he begins carving.
Lower left. With a wood-rasp he rounds off the sharp corners.
Lower right. With a sharp penknife he whittles the piece of
root into shape.

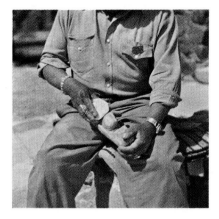
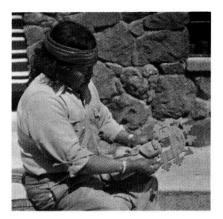
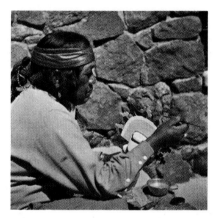
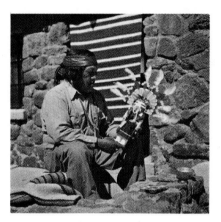

Manufacture of a kachina doll, continued.

Upper left. Jim gives the doll a smooth finish by rubbing it with a piece of sandstone.

Upper right. From another piece of wood he carves a headdress and fits it to the doll.

Lower left. He applies a coat of color over the white underpainting.

Lower right. When the paint is dry, he attaches small bird-feathers, and the doll is completed.

Photographs by Jack Breed.

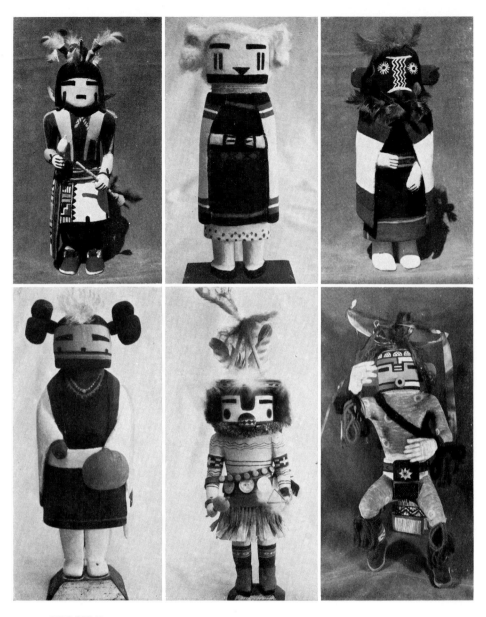

FIGURE 10

Upper. Three kinds of painted mouths. See also Figure 8.
 Left. Rectangular mouth. Bean Dance Kachina (No. 38).
 Center. Triangular mouth. Snow Kachina Maiden (No. 100).
 Right. Crescent-shaped mouth. Zuñi Kachina Maiden (No. 156).

FIGURE 11

Lower. Three types of headdresses. See also Figure 1.
 Left. Maiden-whorls, sides of head. Kachina Maiden (No. 133).
 Center. Tripod of sticks, top of head. Yucca Kachina (No. 172).
 Right. Cross of eagle feathers on top of mask.
Spotted Corn Kachina (No. 122).

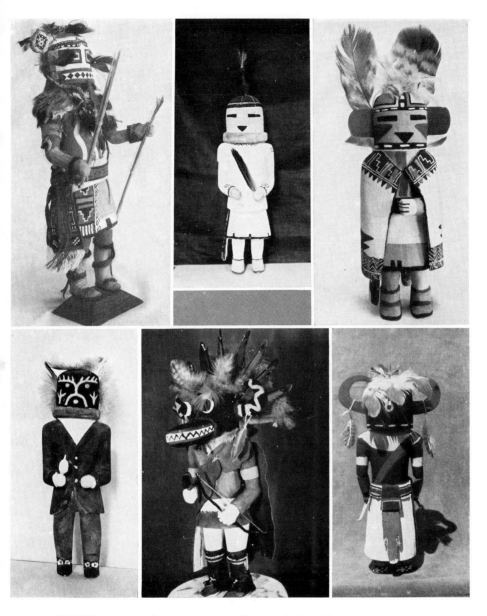

FIGURE 12. Six common types of male kachina costumes.
Upper left. The most common male kachina costume.
An embroidered white cotton kilt, white brocaded sash,
woman's belt, fox skin, no shirt. Hilili (No. 185).
Upper center. The white shirt and white kilt worn by certain
of the kachina officials. Solstice Kachina (No. 1).
Upper right. Kilt, plus an embroidered ceremonial robe
worn as a shawl. Silent Kachina (No. 46).
Lower left. White-man's suit. Qöqlö (No. 5).
Lower center. Velvet shirt, white trousers, red leggings.
Black Ogre Kachina (No. 29). See also Figure 5.
Lower right. Fox skin hanging from belt. Ho-ó-te (No. 104).

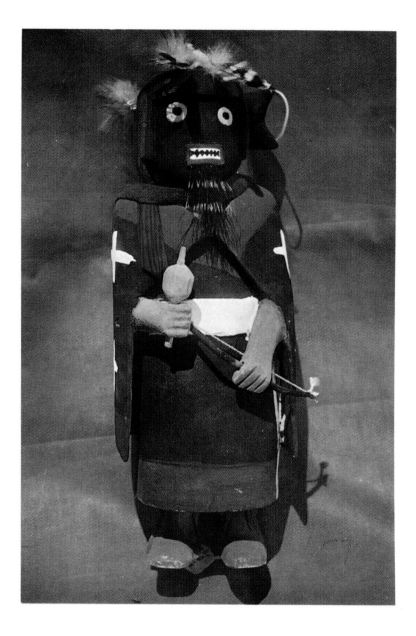

FIGURE 13

A male kachina dressed in female costume, which consists of a black woolen dress and white belt, with another black dress used as a shawl. Hé-é-e (No. 21). *Photograph by Jack Breed.*

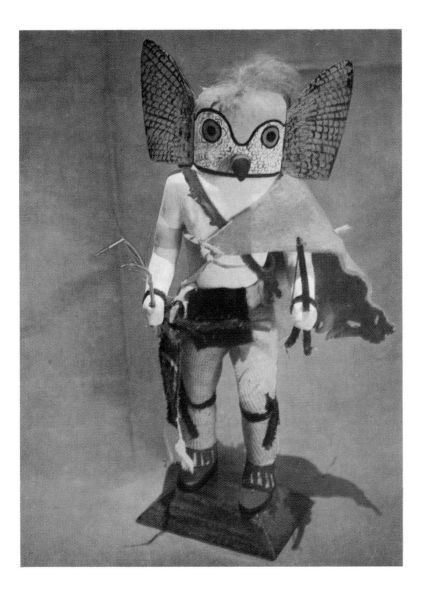

FIGURE 14

A type of headdress carrying wings on the side of the head.
Great Horned Owl Kachina (No. 78). *Photograph by Jack Breed.*

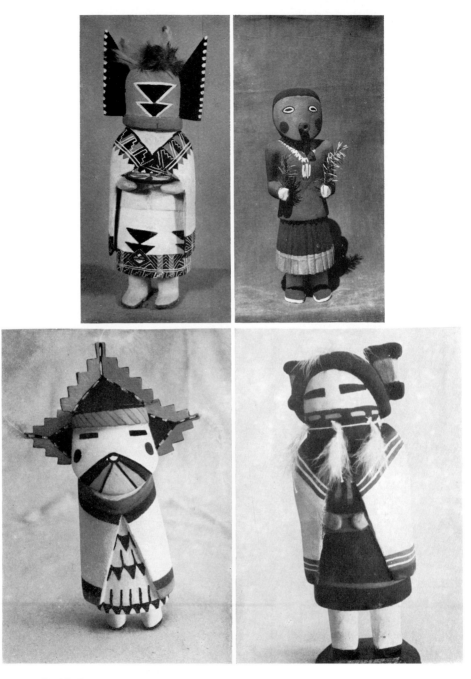

FIGURE 15. Four types of female kachina costume.

Upper left. Embroidered white ceremonial robe worn as a dress, with another dress used as a shawl. Crow Bride (No. 13).

Upper right. Navajo woman's dress, bodice, and skirt. Navajo Kachina Maiden (No. 136).

Lower left. Long skirt of eagle feathers. Salako Maiden (No. 118).

Lower right. Black woolen dress, red belt, and a maiden's white shawl with bands of blue and red. Kachina Maiden (No. 133).

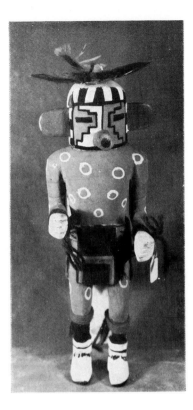

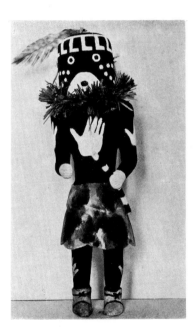

FIGURE 16

Left. Body painted with white circles.
Spotted Corn Kachina (No. 122).

FIGURE 17

Right. Body painted with special symbols;
in this case, white hands. Mastof Kachina (No. 6).

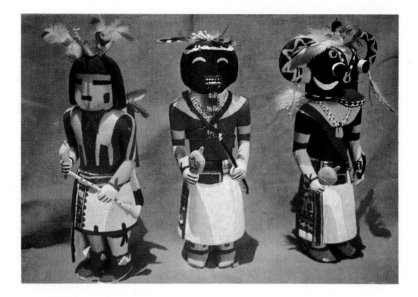

FIGURE 18

Some varieties of body painting. See also Figure 17.
Left. Black body, with right shoulder and left forearm
green, opposite shoulder and forearm yellow.
Bean Dance Kachina (No. 38).
Center. Red body, with yellow neck, shoulders,
and forearms. Chakwaina (No. 160).
Right. Black body, with yellow neck, shoulders,
and forearms. Ho-ó-te (No. 104).
Photograph by Jack Breed.

The following classes of kachinas may be recognized:

(1) About thirty official or Mong (Chief) Kachinas take the principal parts in the major ceremonies, which last nine days, like the Soyalang-eu (Winter Solstice Ceremony) in December, Pamuya in January, when the sun appears to move north again, Powamuya (Bean Ceremony) in February, Palölökonti (Water Serpent Ceremony) in February or March, and the Niman Kachina (Home Dance Ceremony) in July when the sun appears to move south. The Mong Kachinas are probably quite ancient and have their roots deep in the traditions of the people. Although most of the Mong Kachinas are beneficent beings, there are also among them demons and ogres who threaten the children, and so force them to conform to the Hopi culture pattern.

(2) Clowns of several types afford comic relief in the intervals of serious ceremonies.

(3) About seventeen different kinds of Wawarus, Runner Kachinas, run races with Hopi men in the early spring. These masked figures challenge a man to a race. If the man wins, the kachinas give him a present, but if he loses, the kachinas, depending upon the kind of Wawarus, may strip off his clothes, plaster him with mud, cut off his hair with a pair of scissors, or whip him with a yucca leaf whip. The Wawarus make it worth while for Hopi boys to train to be good runners.

(4) There are a large number of kachinas that appear singly or in pairs in the kachina parade at the Bean Ceremony, and in the so-called mixed kachina dances of the spring and early summer.

(5) By far the greater number of kachinas appear in companies of fifteen to thirty, with six or eight female kachinas (kachin-manas), in one day ceremonies. These ceremonies, ordinary or regular kachina dances as they are called, have no fixed dates and are put on by some fraternity or kiva group when the spirit moves them.

Among the kachinas that appear in the one day ceremonies are some ill-defined sub-classes. Hopi informants often refer to *Kwivi* Kachinas. *Kwivi* is translated as proud or sporty and means that the kachinas wear a lot of ornaments. Another group is referred to as *Kuwan* Kachinas. This word means "elaborated with more color" or beautiful. It appears that any kachina can be known as *Kuwan* if the costume is very elaborately made. Another group is known as *Rügan* Kachinas. This means that the female kachinas that accompany the kachinas perform on a musical instrument consisting of a wooden rasp rubbed with a sheep scapula, with a dried pumpkin shell for a sounding board.

(6) Besides the male kachinas are many female kachinas called kachin-manas, which are always impersonated by men. Although a few have distinctive characteristics, the majority look much alike, wear the same kind of costumes, and can only be distinguished by the things they do and the kachinas they accompany.

2. Making a Kachina Doll

WHEN a Hopi man plans to make a kachina doll, he searches along one of the numerous washes near the Hopi mesas or the banks of the Little Colorado River for the dried roots of dead cottonwood trees. Sawing off roots with a diameter of three to four inches, he carries them home. For tools he procures penknife, chisel, wood rasp, and a piece of sandstone.

With the saw and chisel he roughs out, from a length of the cottonwood root, the doll that he has in mind, whittles it into shape with the penknife, smooths it with the wood rasp, and sands it carefully all over with the sandstone. The doll is then ready to receive the additions of snout, nose, horns, and tableta or ears, which are also whittled out of wood and fastened to the doll with tiny dowel pins, little larger than toothpicks. Glue is sometimes used now.

When the carving is completed and the accessories added, the doll is ready to be painted, but before the color is laid on, the craftsman covers the figure with a layer of kaolin as an undercoat. As this undercoat is not bound to the wood, it may peel off, which makes old kachina dolls have a shabby appearance. On the white kaolin surface the artist places his

colors; for green or blue he uses copper carbonate, malachite; for black he procures soot or corn smut, a fungus that grows on corn plants and which has a religious significance; for red, ground hematite (iron sesquioxide); for yellow, limonite (iron hydroxide); for white, kaolin. These are the same substances that the Hopi use as body paints. Today many men prefer to use poster paints, which are often available, which adhere better, and are much brighter, but fade more quickly, than the old native paints which lack a satisfactory binder.

The doll, when painted, is further adorned with the bright feathers of small birds, which represent the feathers of the eagle, parrot, turkey, or other large bird feathers found on a full-sized kachina mask.

We have described the manufacture of a kachina doll from a rounded piece of wood, but Hopis make another kind of a doll for infants. These dolls are crudely shaped out of a piece of flat board about three and one-half inches wide and eight inches long. In these dolls little attempt is made at realism; they are not well finished, the painting is crude, and few feathers are used, yet enough is given so there is never a doubt as to the particular kachina represented. These dolls are particularly valuable because they show only the essential characters.

When a Hopi is carving a doll, like any other sculptor, he simplifies. He leaves out unessential details and stresses those characteristics that he deems important. For example, he may not make a clear distinction between a case or a sack mask, nor does he always indicate the kind of a ruff or even show a ruff at all. Therefore, when we compare a doll with a kachina in a dance, we must look for many differences, but the essential features by which the kachina is identified are never omitted.

No one knows how many kachina dolls the Hopi make as gifts each year, but it is probably not less than five hundred

nor much more than one thousand. The youthful recipients of the kachina dolls often take them to the trading stores where they procure sweets, pop, gum, etc., in exchange, and the dolls end up in curio stores in towns and cities of the Southwest. A few Hopis manufacture dolls for the trade, but many of these do not represent authentic kachinas. In addition, some curio shops sell spurious kachina dolls that Hopis say are made by white men.

During the past few years a new class of kachina dolls has been produced. These differ from the traditional dolls by portraying the kachina in action, as if in a dance. Some are very well carved and finished. All are produced for the tourist trade.

3. Principal Features of Kachina Dolls

THE SUBJECT matter of this book is purely factual and is designed for one purpose only, the identification of kachina dolls. As there are over 266 different kinds, we are confronted by the same problems that naturalists met and solved when they had to distinguish and identify animals and plants. As a first step we will describe each kind of kachina, stressing those characters of mask or costume which distinguish one from another. To assemble this information we have studied all the published illustrations of kachinas and dolls, have photographed dolls, and discussed the pictures and the dolls with Hopis. In these interviews we have discovered kachinas that never have been recorded before.

When we observe a kachina or a doll carefully we find that the mask offers the greatest number of characters for analysis so we will consider the mask first.

Hopis manufacture five types of masks for their kachinas: (a) A face mask made of leather. It is like our masks which we call false faces, and hides only the face, showing the wearer's hair. (b) A half-mask covering the upper half of the face, the lower half being hidden by a beard of hair or

feathers. (c) A circular mask built upon a yucca sifter basket. (d) A spherical sack mask, usually made from an old felt hat by wetting it and stretching it over a rounded post. (e) A case or helmet mask which is the most characteristic kachina mask. It is made of rawhide in two parts, a cylinder to which a circular top piece is sewed. These five types of masks are painted in many ways and often have attached to them various accessories such as ears, noses, snouts, and horns, and most are ornamented with feather headdresses.

The color on kachina masks is symbolic. When a Hopi paints a mask representing an animal or plant kachina, no attempt is made at realism, because he is not representing the object but the spirit of the object, which he visualizes as having human form. Some clue to the object is given, such as a bear track painted on the cheek, which tells the initiated that he is seeing a Bear Kachina. Many kachinas appear in different colors so that one may see yellow, green, red, and white Bear Kachinas, incongruous as it may seem. The color is symbolic and indicates the direction from which the kachina came. The Hopis have six directional colors which are as follows:

> Yellow refers to the North or Northwest.
> Blue-green refers to the West or Southwest.
> Red refers to the South or Southeast.
> White refers to the East or Northeast.
> All the above colors taken together refer to the Zenith or up.
> Black refers to the Nadir or down.

When a kachina or part of a kachina is painted with all these colors in stripes, dots, or circles, we will use the term "all colors."

The features on the top and side of the head: We must look for bird wings usually from a crow or an owl. Ears, when present, are usually large and red. When ears are absent they

may be replaced by datura (Jimson weed) flowers made out of corn husks, or by bunches of hair, or feathers. On other kachinas, horns are prominent features.

Symbols are often painted on the forehead or cheeks of the mask and are important distinguishing marks. The principal symbols are:

a. Animal and bird tracks.
b. Celestial symbols such as clouds, lightning, sun, moon, and stars.
c. Vegetable symbols: corn, flowers, cactus, etc.
d. A pair of vertical lines under the eyes represent the footprint of a warrior.
e. An inverted "V" over the mouth indicates certain kachina officials.
f. Phallic symbols represent fertility.

EYES: The real eye holes through which the impersonator sees are small circular holes or narrow slits and usually have no relation to the visible eyes painted on or attached to the kachina mask.

a. Painted eyes may be round, rectangular, pot hooks, or half moons.
b. Pop eyes are carved of wood and attached to the mask.

NOSES: Realistic noses are seldom seen, and when they are, they are carved of wood like the nose on the mask of the Cross-legged Kachina.

MOUTHS: The mouth through which the impersonator breathes is a round hole in the mask and may have no relation to the mouth of the mask. Mouths are either painted on the mask, or a beak, tube, or snout is carved in wood or made of some other material, such as corn husks, and added to the mask. Painted mouths may be round, rectangular, triangular, half-moon shape, or a long line with painted teeth across the whole front of the mask.

BEARDS: Some kachinas have beards of red-dyed horse hair or of feathers.

HEADDRESSES: Most masks carry on top a headdress of some sort, made of feathers, hair, or wool. Others support tripods or elaborate painted and feathered tabletas of wood.

RUFF: To hide the junction between the case mask or sack mask and the body, a ruff made of fox skin, Douglas fir branches, juniper branches, a cloth roll, or in some cases old rags, is worn.

COSTUMES: Although a few Hopi kachinas wear distinctive costumes, most fall into about thirteen costume classes. Probably half of all kachinas are dressed alike.

a. Many official Mong Kachinas wear a white, handwoven, cotton shirt, a white, handwoven, cotton kilt, a braided, white, cotton wedding sash, and green moccasins, like Ahöla, No. 2, or Eototo, the Kachina Chief, No. 7.

b. The typical kachina costume characteristic of over seventy kachinas, consists of a white, handwoven, cotton kilt with embroidered ends, called a kachina kilt, and a man's white, handwoven sash with brocaded ends, called a kachina sash, over which is worn a woman's narrow belt in red, green, and black. A fox skin, suspended from the sash, hangs down behind. The upper part of the body is unclothed but painted. The moccasins are usually red, but may be green.

c. The ordinary modern Hopi full dress costume is a black velvet shirt, trousers split at the ankles and made of white commercial cloth, Hopi knit wool leggings, Hopi woven wool garters, and red moccasins, and is commonly worn by some kachinas, like Nataska, No. 28.

d. A white man's coat and trousers, said to replace a more ancient buckskin suit, is worn by Qöqlö, No. 18.

e. A few kachinas wear a kilt of rawhide, as does Mastof, No. 6; a kilt made of a woman's old dress, as Qöchaf, No. 19; or a kilt of red flannel, as Palavikuna, No. 57. These kachinas are very often barefooted.

f. Some kachinas wear a robe over their shoulders, which may be: an animal skin over one shoulder; a special painted robe covering both the shoulders, like Aholi, No. 8; a woman's handwoven white cotton wedding robe covering both shoulders; a woman's embroidered ceremonial robe; or a maiden's shawl, handwoven of white cotton with borders in red and blue.

g. Many kachinas, particularly the Whippers and the Runners, wear only a black, handwoven, wool breech clout, like the Hú Kachinas, No. 14, or Ala, No. 48.

h. Two kachinas are stark naked, wearing only a belt around the waist. These are Kokosori, No. 9, and Qalavi, No. 17. Some others are occasionally portrayed naked, such as Momo, No. 67, but nowadays they usually wear at least a breech clout.

i. The costume of a female kachina whether an ogre or a maiden varies very little. The costume consists of a Hopi woman's black, woolen, handwoven dress, held in at the waist by a woman's belt, handwoven of red, green, and black wool in warp-floating technique. Over her shoulders she wears either a white, handwoven, cotton shawl with red and blue borders, called a maiden's shawl, or a white, embroidered ceremonial robe. The latter is made from a woman's white, handwoven wedding robe. Kachin-manas may be bare-footed or wear white deerskin boots.

j. If a bride is represented, the kachina wears a white, handwoven, cotton wedding robe, held in at the waist with a white, cotton, braided wedding belt with long fringe. Over her shoulders she will probably wear, besides, a white, embroidered ceremonial robe.

BODY PAINT: As many kachina costumes cover only part of the body, there is plenty of scope for the use of body paint. The base of these paints is clay, colored by pulverized minerals, hematite for red, limonite for yellow, malachite for blue-green, and kaolin for white. For black, soot may be used, or for a brownish-black the Hopi can use corn smut. There is a bluish body paint prepared from mud from the bottom of springs.

As the patterns used in painting the body fall into a few large classes, they are of little use in distinguishing one kachina from another. However, some kachinas have patterns sufficiently characteristic to be useful in description. These are mentioned in Chapter 4.

ACCESSORY OBJECTS: Kachinas most commonly carry in their hands rattles made from gourds, and branches of Douglas fir, and wear attached to one leg, below the knee, tortoise shell rattles and sleigh bells. The two latter are never shown on kachina dolls. However, a certain number of kachinas can best be distinguished by the objects that they carry,

and these objects are attached to dolls. Some carry bows and arrows, others carry crooks with which to catch children, or staffs, and still others have scissors to cut off the hair, butcher's knives, etc. Many female kachinas, kachin-manas, can only be told apart by the color of the corn that they carry in a tray.

FIGURE 19
Symbols commonly used on kachina masks.

4. Descriptions of Kachina Dolls

THE LIST of kachinas in this chapter makes no pretense of being complete or even perfectly correct. Although compiled from all available printed sources and from the descriptions by Hopi informants, one checked against the other, in many cases the author has had very little to go upon. He hopes the reader will not be too critical of his efforts.

As the names of kachinas have been reported by many persons using different systems of spelling, and since the names by which the kachinas are known are not the same for all Mesas, in order to reduce the terminology to some system, the author has given preference to the Second Mesa name when it was known. Wherever possible an English equivalent is given for the Hopi name, but in many cases this is not possible for some kachinas are named for the sound that they utter and there is no English equivalent.

The spelling of Hopi words in this book gives a key to their pronunciation, if we keep in mind that the vowels have the same values as in Spanish and the consonants follow English usage. Hopi has two sounds that cannot be represented with ordinary English letters: a vowel represented by *ö* with a

sound like *oeu* in *oeuf,* in French; and a consonant, a glottal stop further back in the throat than the English *k.* This is represented by the letter *q* not followed by *u.* In order to separate two vowels or consonants that occur together and are pronounced separately, a hyphen is used.

Names of little-known kachinas which do not appear in the key are preceded by an asterisk.

1. Soyal Kachina Solstice Kachina

Green case mask without ears. At Second Mesa the mask has feathers on the top and diagonal hachures on the cheeks; at Third Mesa the mask has a gourd on top and no diagonal hachures on the cheeks. Fox skin ruff. The kachina wears a white shirt of handwoven, cotton cloth, a white kilt, and red moccasins, carries a rattle and a handful of *natcis,* bows decorated with feathers.

Second Mesa

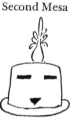

The Soyal Kachina is the first kachina to appear at the time of the winter solstice. The Hopis believe that he taught them to make prayer offerings called *pahos.*

Earl and Kennard, 1938.*

Third Mesa

2. Ahöla The Germ God Kachina, Mong Kachina or Chief Kachina

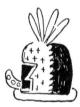

Circular mask made from a yucca sifter basket covered with cloth and painted, one third green, one third yellow, and the lower third painted black. Black stars are painted on the yellow and green portions. The mask has a wooden beak usually turned up. Fox skin ruff. The kachina wears a white shirt, white kilt, sash, woman's belt, and green moccasins. Usually carries a gourd full of sacred water and a ceremonial wand.

Ahöla appears at the Solstice and Bean Dance Ceremonies and is said to represent the spirit of the Germ God, Alosoka, who controls the growth and reproduction of all things.

Fewkes, 1901, 1903; Voth, 1901; Stephen, 1936.

* The references at the end of each description indicate works in which illustrations and descriptions are found. They are not necessarily the source of all the information used in the descriptions, which also include hitherto unpublished material.

3. Ahöla Maid Germ God Maiden

Half mask similar to many other kachina maidens. She wears a woman's costume and carries a tray of corn. Ahöla Mana appears with Ahöla at the Solstice Ceremony.

Fewkes, 1903.

4. Qaletaqa Warrior Kachina

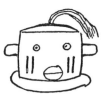

Green case mask of either of two types: one with warrior marks on the cheeks, pop eyes, and a snout; and the other without warrior marks and with painted eyes and mouth. Fox skin ruff. Wears a kachina kilt, sash, fox skin, and red moccasins. Body painted black with large white spots. He wears a bandolier over one shoulder and carries a bull-roarer, as well as bows and arrows. He appears with Ahulani, No. 164, in the Solstice Ceremony at First Mesa. Not reported from other Mesas.

Fewkes, 1903; Stephen, 1936.

5. Qöqlö

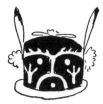

Case mask painted black with white markings representing bird tracks; feathers on head are from all kinds of birds. Douglas fir ruff. Wears a white man's suit of coat and trousers, but originally a buckskin suit, red moccasins. Carries a rattle.

This generous and kindly kachina comes in pairs usually four nights before the Bean Dance and prophesies good crops and promises toys for the children. At Third Mesa he appears in the Solstice Ceremony also.

Fewkes, 1903; Dorsey and Voth, 1901.

6. Mastof Kachina

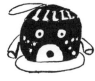

Black case mask with white dots on face which represent constellations: on the right side the Pleiades, on the left side the Dipper; frogs are painted on the back of the mask. Grass ruff. Kilt is a woman's dress, worn-out and discarded, but in the old days it is said to have been a wildcat skin. Red moccasins. Body painted black with a white hand painted on the chest. He carries a rattle and throwing stick.

Mastof is said to represent the Spirit of the Earth God, Masao. His function seems to be procreation. He appears in initiation years at Second and Third Mesas at the Solstice Ceremony.

Dorsey and Voth, 1901; Earl and Kennard, 1938.

7. Eototo Kachina Chief

White case mask without ears. Douglas fir ruff. He wears a white shirt and kilt, sash, and a hank of blue yarn over one shoulder, white knitted leggings, red moccasins, carries a gourd of sacred water, and a small wand.

Eototo is chief of all the kachinas and knows all the ceremonies. He controls the seasons and is a leading figure in the Bean Dance.

Fewkes, 1894, 1903; Voth, 1901; Earl and Kennard, 1938.

8. Aholi Kachina Chief's Lieutenant

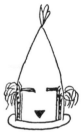

High conical mask with tufts of hair in place of ears. Fox skin ruff. He wears a white kilt, sash, fox skin, and a painted blanket with a likeness of the Germ God over his shoulders. On his feet are red moccasins. Carries a staff or wand. Aholi appears at the Bean Dance as a companion of Eototo.

Voth, 1901; Earl and Kennard, 1938.

9. Kokosori

Sack mask painted black with spots of red, blue, yellow, and white with downy feathers on top. This kachina is naked except for a woman's wedding sash about his waist. His body is painted black with corn smut and has spots of all colors representing colors of kernels of corn. In his hands he carries two wooden hooks, the size of lead pencils. Kokosori accompanies Eototo and Aholi. The part is usually played by a young boy.

10. A-ha

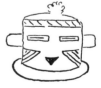

Green case mask, eyes purple and black. Two hanks of colored yarn across the forehead. Fox skin ruff. Robe of wildcat skin, red moccasins. No accessories.

A-ha comes only on Second Mesa with A-höla and is accompanied by a kachina mana at the Bean Dance.

11. A-ha Kachin-mana

Half-mask similar to Kachin-mana, No. 133. She wears a woman's dress and carries no objects in her hands.

12. Angwusnasomtaqa or Tumas Crow Mother

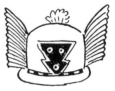

Green case mask with crow wings on the side. Fox skin ruff. She wears a woman's dress and ceremonial robe with green moccasins. At Oraibi she carries a yucca whip, at Second Mesa a tray of corn.

The Crow Mother is mother of the Hú Kachinas and appears in the Bean Dance. By some Hopis she is considered to be the mother of all the kachinas. Her Hopi name translated means "Man with Crow Wings Tied to."

Fewkes, 1894, 1903; Stephen, 1936; Earl and Kennard, 1938.

13. Angwushahai-i Crow Bride

Case mask similar in every way to that of the Crow Mother. Instead of a black dress she wears a white wedding dress and carries in her hands a plaque with corn. There is some confusion in the minds of Hopis with regard to the Crow Bride and Mother. Some consider them to be separate kachinas, while others think that they are the same kachina in different acts of a drama where the kachina appears in one act as a bride, and in another as a married woman.

Fewkes, 1894; Earl and Kennard, 1938.

14. Hú Kachina or Tungwup Whipper Kachina

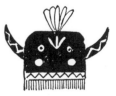

Black case mask with white spots on the cheeks, white turkey track on forehead, long beard, horns on the side of the head. Fox skin ruff, breech clout and red moccasins. Body painted black with white spots. Carries yucca leaf whips and pieces of cholla cactus.

Hú Kachinas appear at the Bean Dance with the Crow Mother and whip children.

Dorsey and Voth, 1901; Voth, 1901; Fewkes, 1903; Earl and Kennard, 1938; Stephen, 1936.

15. Tungwup Ta-amu Green Faced Hu Kachina, or Whipper Kachina's Uncle

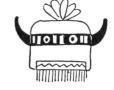

Green case mask, beard, horns on side of head. Fox skin ruff. Costume is a maiden's shawl used as kilt, and a wedding sash. Carries a yucca whip. He sometimes acts as leader in the Bean Dance Parade. By some Hopis he is not distinguished from other Hú Kachinas.

Fewkes, 1903.

16. Pachavu Hú Kachina Pachavu Whipper Kachina

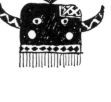

Black case mask with white spots under eyes, on left side of forehead cross-hatching in white, horns on side of head. Fox skin ruff. Wears a kilt and sash, fox skin, and red moccasins. Body painted white.

This kachina appears only at the Bean Dance in the initiation years and guards the bean plants in the kiva.

17. Qalavi

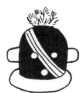

Black case mask with diagonal line of red bordered by two green lines across the face between the eyes. Fox skin ruff. Qalavi is naked except for a copper green belt around his waist. Body is painted black with corn smut. Qalavi carries a yucca leaf whip and a bit of cholla cactus.

At Second Mesa he holds the children that are to be whipped by the Hú Kachinas.

18. Ongchoma Compassionate Kachina

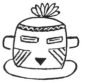

Green case mask, eyes purple and black, triangular mouth, and cheek hachures black. Fox skin ruff. Mask similar to A-ha, No. 10. Body is painted red with one green and one yellow shoulder in regular kachina style.

Ongchoma carries a mano in his hand and appears in the Bean Ceremony during initiation. He is a very compassionate kachina who sympathizes with the children who are about to be whipped and touches them with the mano to make them tough so they will not feel the whip.

19. Qöchaf Kachina Ashes Kachina

White case mask with black band across eyes which are vertical bands. Ruff of crow feathers. He wears a kilt and a woman's old dress and is barefooted. His body is painted white and he carries branches of squaw berries to which pahos are attached.

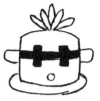

Qöchaf appears at the Bean Dance only at Shungopovi and Shipaulovi. His function is to purify everyone and all things.

20. Chowilawu Terrific Power Kachina

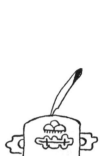

This kachina is supposed to be invisible, and so never appears in public dances, and is said never to be represented by dolls. However, several dolls have been identified from old collections. Therefore I am adding the figures of two varieties.

Second Mesa

Third Mesa

Second Mesa: a case or sack mask painted white similar to No. 19. Crow feather ruff. Wears a woman's old dress as a kilt and is barefooted. Body is painted white.

Third Mesa: a white sack mask and no ruff. Kilt of red horse hair, a green belt, and fox skin. Body paint is white with a black smudge in the region of the sternum. He carries a bull-roarer.

Chowilawu appears once in a great while four days before the Niman Kachina Dance when someone is to be initiated into the Pawamu fraternity. He is never seen by the public and is supposed to be invisible. He is not often represented by dolls. Some Hopis consider him to be the same kachina as Qöchaf only more powerful. Some Hopis associate him with the whirlwind.

Voth, 1901.

21. Hé-é-e

Black face mask with a beard, maiden whorl on one side of head and hair hanging loose on the other. Wears a woman's dress, and a shawl made from another dress, wedding sash, and red moccasins. He carries a bow, arrows, quiver, and a rattle. Hé-é-e is a male kachina dressed in woman's clothes.

At Second Mesa Hé-é-e is supposed to be the spirit of a

young man, who, while changing clothes with his bride in a corn field, was half dressed when he spied enemies approaching his village. Retreating to his village he rallied the defenders which led to the defeat of the enemy. His hair was only arranged like a woman's on one side and he wore pants under his dress. At Oraibi the story is different. Hé-é-e is a young woman who was interrupted, while her mother was fixing her hair, by an attack on the village. She rallied the men and defeated the enemy.

Fewkes, 1894, 1903; Voth, 1901; Earl and Kennard, 1938; Wallis and Titiev, 1944.

22. Wuyak-ku-ita Broad-faced Kachina

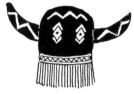

Mask is made from yucca basket covered with cotton cloth painted black and sprinkled with gypsum fragments to give it a glittering appearance. His teeth are made of neatly twisted corn husks and the beard of horse hair.

Wuyak-ku-ita appears in the Bean Dance at First Mesa with Soyoko. Voth, 1901; Stephen, 1936.

23. Pachavuin Mana

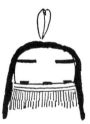

Half mask painted orange, with beard. She may appear with hair arranged as a maiden or a married woman. She wears a woman's costume and maiden's shawl and carries a tray of bean sprouts.

Pachavuin Mana appears in the Bean Dance Parade as a maiden or married woman.

Voth, 1901; Fewkes, 1903.

24. Soyoko An Ogre Woman

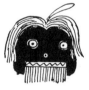

First and Second Mesa: Black case mask with wide horizontal mouth and beard. Third Mesa: The mask has a beak with tongue hanging out and no beard.

Fox skin ruff. Wears a woman's black dress with a second one for a shawl, wedding belt, and white boots. Carries a butcher knife and a cane with a crook to catch her prey.

Soyoko is an ogre woman who appears in the evening after the Bean Dance. She visits various houses and asks the boys to hunt game—mice and rats—for her, and threatens that if they do not have some for her in

four days' time she will eat them instead. In the same way she requires the girls to prepare for her a paper-thin wafer bread called "piki," made from blue, yellow, or pink corn meal.

Fewkes, 1894, 1903; Voth, 1901; Earl and Kennard, 1938; Stephen, 1936.

25. Awatovi Soyok Wu-uti Awatovi Ogre Woman

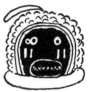

Black case mask with two white stripes on cheeks, pop-eyes, snout with teeth, but no beard. Costume and accessories are like Soyoko. She may carry a saw instead of a knife and, instead of a crook, a burden basket in which to put children. She is an ogre woman, apparently an Awatovi variant of Soyoko. She appears at the Bean Dance only at First Mesa. Fewkes, 1903.

26. Awatovi Soyoktaqa Awatovi Ogre Man

Case mask painted white with pop eyes, snout, and hair hanging over face. Wears a breech clout and rabbit skin blanket shawl and carries a burden basket and saw.

He appears sometimes at First Mesa and seems to be an Awatovi variant of the White Ogre, No. 31. Fewkes, 1903.

27. Soyok Mana

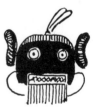

Black case mask with white chin, green eyes, broad mouth, with horse-hair beard; hair in maiden whorls. Wears a black dress and buckskin shawl and carries a burden basket and a knife. At First Mesa she accompanies Soyoko on collecting trips. Fewkes, 1894; Stephen, 1936.

28. Atosle An Ogre

Hopis differ on Atosle. In one conception the kachina is female with case mask painted lavender and yellow, pop eyes. Hair falls over face. Fox skin ruff. Wears a woman's black dress, maiden's shawl, and white boots. She carries a knife and a burden basket.

She is an ogre woman of Zuñi origin and accompanies Soyoko on her collecting trips but does not play a leading part. Some Hopis consider Atosle to be a male variant of Nataska, No. 29, but with a little shorter snout. Otherwise, the mask and costume are the same. Fewkes, 1903, shows the male form. Bunzel, 1932, shows the Zuñi female form.

29. Nata-aska Black Ogre

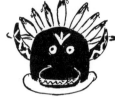

Black case mask with large movable jaws, green crow foot painted on forehead. Wears a buckskin or velvet shirt, white trousers or long white under-drawers, red buckskin leggings and moccasins, a silver belt. Carries a saw and bows and arrows.

Nata-aska accompanies Soyoko on her trip collecting food from the children. He is supposed to be able to swallow children whole.

Fewkes, 1894, 1903; Stephen, 1936.

30. Tahaum Soyoko The Black Ogre's Uncle

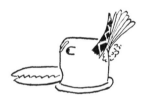

Black case mask, snout with teeth, side horns, hair hanging over face, green "V" back of eyes. Fox skin or cloth ruff. Wears a velvet or white shirt, white pants and red moccasins. Carries bow, arrows, and rattle.

Fewkes, 1903.

31. Wiharu White Ogre

Mask similar to Nata-aska only painted white. Costume is an ordinary velvet Hopi shirt, white trousers, red moccasins and leggings, silver belt. Carries a saw and a bow and arrows.

He accompanies Soyoko on collecting trips.

Fewkes, 1903; Stephen, 1936; Earl and Kennard, 1938.

32. Toson Koyemsi Mud Head Ogre

Sack mask painted brown, green lines on cheek and fore-head, round eyes and a mouth made of corn husks; rag ruff. He wears a kilt as a breech clout, black shirt or blanket, woman's belt, knitted leggings, and red moccasins. His body is painted red and he carries no objects.

A number of these come with Soyoko after the Bean Dance and demand sweet cornmeal from the girls.

33. We-u-u

At Second Mesa: A sack mask painted lavender with diagonal white line with red borders across the face, cloth ruff. He used to wear a wildcat skin but now usu-ally wears a blanket and red moccasins.

Second Mesa

Third Mesa

His body is painted white, and he carries a pole six to seven feet long. At Third Mesa he wears a case mask copper green on one side of a diagonal white line and bronze on the other, tube mouth.

He accompanies Soyoko but says nothing. He usually sits down and often falls asleep.

34. Heheya

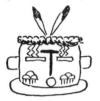
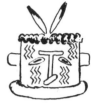

Case mask painted green or yellow, mouth round, oval or diagonal, vertical zigzag lines on face, nose represented by a painted "T," Douglas fir ruff. Wears kilt and sash, green moccasins, body painted red with yellow shoulders. He carries a rattle.

Heheya appears in pairs with Soyoko.

Fewkes, 1894, 1903; Stephen, 1936.

35. Heheya Kachin-mana

Face mask with vertical zigzag lines like Heheya. She wears a woman's dress, maiden's shawl, and white boots. She carries a Douglas fir branch in her hand.

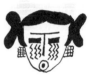

Heheya Kachin-mana is the sister of Heheya and appears in the Bean Dance at Second Mesa.

Fewkes, 1903.

36. Heheya-aumutaqa Heheya's Uncle

Case mask painted white with vertical red zigzags. On the back of the mask is a goat skin, hair side out. Piñon branch ruff. He wears a breech clout, sheep skin belt, knitted leggings, and red moccasins.

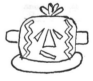

He guards the Heheyas as they rest between incidents in the ceremony.

Stephen, 1936; Fewkes, 1903.

37. Chaveyo An Ogre Kachina

Case mask painted black with green mark on forehead representing a

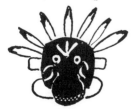
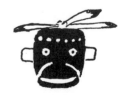

snipe track and white moon symbols on cheeks, snout with teeth, wildcat skin ruff. Velvet shirt, white trousers. Carries a knife.

Chaveyo may come at any time during the spring months

First Mesa

Third Mesa

if Hopi children are particularly bad. "The boogie man will get you if you don't watch out."

Voth, 1901; Fewkes, 1903; Stephen, 1936; Nequatewa, 1948, p. 60.

38. Powamui Kachina Bean Dance Kachina

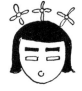

In night ceremonies he wears no mask, but in the plaza ceremonies he wears a red face mask with diagonal hachures on the cheeks. In his hair are all kinds of flowers carved out of wood. Wears a kilt, sash, and red moccasins. Body painted red with one green and one yellow shoulder.

Powamui Kachinas appear in groups and are the most important actors in the Bean Dance.

Voth, 1901; Fewkes, 1903; Stephen, 1936.

39. Powamui So-aum Grandmother of Powamui Kachinas

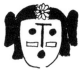

She wears a white face mask with a flower on her forehead, hair may be in maiden whorls or arranged as a married woman's. Wears a woman's dress, maiden's shawl, white boots, and carries a Douglas fir branch.

She is one of a group of gossipy old hags who accompany the Powamui Kachinas in the Bean Dance.

Voth, 1901; Fewkes, 1903.

40. Hó-e or Wó-e

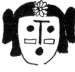

White face or sack mask, red chevron across nose, lamb skin wig. Wears a kilt, sash, and fox skin but is barefooted. His shoulders are painted white and he carries a rattle.

Hó-e used to appear in the parade of the Bean Dancers but he has not appeared for so long a time that his songs are nearly all forgotten.

Fewkes, 1903; Stephen, 1936.

41. Wupomo Kachina Long-billed Kachina

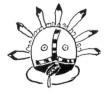

The mask is constructed over a yucca sifter basket, lower half black, one side of the top yellow and the other green. He has a long bill with the tongue hanging out. Wildcat skin ruff. Wears a kilt, sash, fox skin, and green moccasins. Body painted red with one shoulder yellow and one green. Carries a bow and arrows.

Wupomo is a furious kachina appearing during the Bean Dance Ceremonies. Sometimes he stands guard on the kiva when secret ceremonies are taking place.

Fewkes, 1894, 1903; Stephen, 1936.

42. Tanakwewa

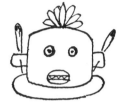

Case mask painted white, pop eyes, built-out mouth, and fox skin ruff. He wears a kilt and sash but is barefooted. His body is painted white. About his waist are turtle shells. This kachina is an important Bean Dancer Kachina at Mishongnovi in the initiation years.

43. Ösökchina Cholla Cactus Kachina

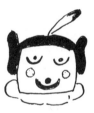

Green case mask, pop eyes, built-out mouth. Cactus blossoms painted on cheeks, fox skin ruff, kilt, sash, fox skin, and red moccasins. Body painted yellow all over. Carries a rattle.

44. Hahai-i Wu-uti Kachina Mother

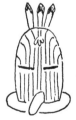

She wears a white sack mask with red spots painted on her cheeks, fox skin ruff, woman's dress, and maiden's shawl. She may be barefooted or wear white boots. She usually carries a gourd filled with water.

She is said to be the mother of all the kachinas (compare with No. 12, Crow Mother), and is a principal actor in the Water Serpent Ceremony. She may appear at other ceremonies such as the Niman Kachina Dance.

Voth, 1901; Fewkes, 1894, 1903; Stephen, 1936; Earl and Kennard, 1938.

45. Tsitoto Flower Kachina

Tall, thin, sack mask painted with concentric bands of many colors as viewed from the side, red, yellow, green, and black. Douglas fir ruff. Regulation kachina costume with kilt, sash, woman's belt, and fox skin behind. The body paint is red and yellow. Carries Douglas fir branches in his hands.

Tsitoto takes part in the Water Serpent Ceremony, and in the Mixed Kachina Dances.

Fewkes, 1903; Stephen, 1936.

46. Nakiachop Kachina Silent Kachina or Salako Warrior

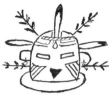

Green case mask; on the cheeks either diagonal stripes of colored yarn or painted cloud symbols. Mouth is painted and triangular. Douglas fir ruff. Kilt, woman's belt, maiden's shawl or cere-monial robe.

First and Second Mesas

Third Mesa

Appears in the Water Serpent Ceremony and the Bean Dance. This is said to be the kachina of the prehistoric Ladder Dance. (See Nequatewa, M. N. A. Bull. 8, 2nd Ed., 1947, pp. 111-115.)

Voth, 1901; Stephen, 1936.

47. Wawarus Runners, a Class of Kachinas

We now come to a class of about seventeen different kachinas who run races with Hopi men in the spring. If a Wawarus Kachina catches the man with whom he races, he chastizes him in some way—whipping him with a yucca whip, throwing mud all over him, or doing some other unpleasant thing. If the man wins the race the Wawarus gives him a present. The kachinas that the Hopis consider as Runners are Nos. 48-58, 64, 72, 110, 182-184. Wawarus usually, but not always, have large eyes and mouths so as to see well and breathe easily when running.

48. Aya A Runner

Case mask without obvious mouth; swastika-like figure in circle on each side of the mask. Breech clout and sash. Body paint may be any color but is usually white or red with yellow bird tracks. Carries a yucca leaf whip.

Fewkes, 1903.

49. Wik-china Greasy Kachina, a Runner

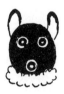

Black sack mask with white circles around the mouth and eyes. Fox skin ruff. Breech clout and red hair skirt, blue belt. Fox skin hangs down back. Body painted black with pink neck, forearms, and lower legs. Carries a yucca leaf whip and smears his victims with black paint. He acts as a guard or "policeman" in the ceremony of cleaning the springs.

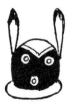

Fewkes, 1903.

50. Novantsi-tsiloaqa A Runner. "He Strips You"

Sack mask, painted yellow on one side and blue on the other at Second Mesa, and red on one side and yellow on the other at Oraibi. Ruff, a rag. Breech clout. One side of body painted yellow, the other side green. Carries a yucca leaf whip. When he catches his victim he strips off his shirt.

51. Hömsona A Runner. "He Cuts Your Hair"

Black case mask with a tube mouth. Red, green, and yellow horizontal stripes on forehead. Fox skin ruff, kilt, sash, fox skin. Body painted black or red, green, and yellow. He carries a pair of sheep shears, scissors, or a knife, which he uses to cut off pieces of the victim's hair.

Second Mesa

Third Mesa

Fewkes, 1903; Stephen, 1936.

52. Puchkofmoktaqa A Runner. Scorpion Kachina or Throwing Stick Man

Sack mask painted yellow with black warrior stripes on cheeks. Rag ruff, breech clout. Body painted yellow with two green stripes. He carries one or two rabbit sticks which he will throw at the Hopi man he is racing with.

Fewkes, 1903.

53. Chöqapölö A Runner. Mud Kachina

A yellowish mud colored sack mask with tansy mustard plants on top. Rag ruff. Breech clout. He carries balls of mud which he smears on his victims.

Fewkes, 1903.

54. Kopon Kachina A Runner. Globe Mallow Kachina

Yellow sack mask. Rag ruff. Breech clout. Yellow body paint. He carries a yucca leaf whip and whips his victims.

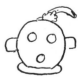

55. Sikyataqa A Runner. Red Fox Kachina

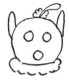

Yellow sack mask with feathers on top of head. Rag ruff, Breech clout. Yellow body paint. He carries a yucca leaf whip to whip his victims.

56. Kona A Runner. Chipmunk Kachina

Yellow case mask with tube mouth, with black, white, and red vertical stripes between the eyes. Rag ruff. Breech clout. Body painted yellow all over with stripes on back similar to those on the head. He carries a yucca leaf whip and whips his victims.

Fewkes, 1903.

57. Palavikuna Red Kilt Runner

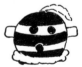

Black case mask. Rag ruff. Red cloth kilt and no sash. Body painted black with yellow neck, forearms, and lower legs. He whips his victims.

Fewkes, 1903.

58. Sivuftotovi A Runner. Dragon Fly Kachina

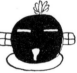

Black case mask with red horizontal stripes. Rag ruff, breech clout. Body painted black all over. He carries a yucca leaf whip and a container of corn smut, which he smears on his victims.

Fewkes, 1903; Stephen, 1936.

59. Koyemsi The Mud Head Clown

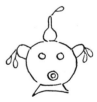

Reddish brown sack mask to which are fastened three gourds, one on top and one over each ear, and painted reddish brown. Rag ruff. Kilt made from a woman's old dress. Body painted with red-brown clay. He carries a feather and a rattle. Koyemsi is the most common Hopi clown. He appears in Mixed Kachina Dances and sometimes a group of Koyemsi appear in a dance of their own. At First Mesa they are said to sing Zuñi songs.

60. Paiyakyamu or Hano Chukuwai-upkia Hano Clown or Koshare

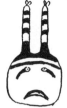

Face mask painted white with black eyes and mouth. Two soft black and white striped horns on top of head. Rag ruff. Breech clout. Bare feet. Body painted in black and white horizontal stripes. No regular accessories.

Fewkes, 1903; Stephen, 1936.

61. Piptuka A Clown

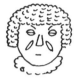

White face mask with hair of white lamb's hide, nose carved out of cottonwood, red paint on cheeks. Rag ruff. The rest of the costume is made up any way to appear funny.

Fewkes, 1903; Stephen, 1936.

62. Tsuku Rio Grande Clown

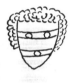

Brown face mask with two horizontal red bands. Rag ruff. Breech clout. No body paint.

Fewkes, 1894, 1903.

63. Kaisale A Clown

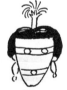

Reddish brown face mask with two horizontal blue lines bordered by red. Rag ruff. Breech clout. Body painted in green, blue, green-blue, and red bands.

Fewkes, 1903.

64. Susöpa Cricket Kachina

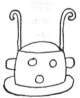

Muddy yellow case mask, with pseudo-horns on top of head resembling antennae. Rag ruff, and breech clout. Carries a yucca leaf whip.

65. Kokopölö or Kokopelli Assassin or Robber Fly Kachina or Hump-backed Flute Player Kachina

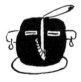

Black case mask with a white line made of felt running vertically from the bill over the top of the head; bill made of corn husks, straight at Second Mesa, turned up at Third Mesa; abalone shell earrings. Fox skin or rag ruff. Breech clout and sash, and sometimes trousers. At Third Mesa wears a white shirt with orange stitches. Humped back is most characteristic feature. May carry a stick and rattle.

Kokopölö appears in the Mixed Kachina Dance. He is identified with the Humped-back Flute Player when he borrows a flute from Lenang,

the Flute Kachina. There is reported to be a green-faced variety called
Kuwan Kokopölö which wears a velvet shirt, white pants, etc.

Fewkes, 1903; Stephen, 1936; Hawley, 1937.

66. Kokopölö Mana or Kokopelmana Kokopelli Maiden

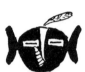

Black case mask, white line and bill like Kokopölö, but
with hair done up in maiden's whorls. Woman's dress,
maiden's shawl. Humped back and barefooted. She carries
a bundle of food and appears in Mixed Kachina Dance.

Fewkes, 1903.

67. Momo Kachina Bumblebee Kachina

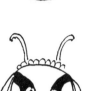

Case mask painted yellow with two black bands. Fur or
Douglas fir ruff. Kilt, sash, fox skin, and green moccasins.
Yellow and red body paint. Momo carries a bow and
arrows. Appears in Mixed Kachina Dance and Water
Serpent Ceremony.

Fewkes, 1903; Bunzel, 1932; Stephen, 1936.

68. Tata-nga-ya Hornet Kachina

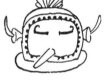

Two types. At First Mesa he wears a
horizontally striped sack mask with two
soft horns on top of head made of fabric
stuffed, and with a sharp bill. At Second
and Third Mesas he wears a green case
mask with datura flower ears. Stripes
of all colors surround the face. Cloth

First Mesa

Second and Third
Mesas

ruff, breech clout, and green moccasins. Yellow and red body paint. The
Hornet Kachina appears in groups or singly in Mixed Kachina Dance, and
the Pamuya. He is said to be of Zuñi origin. Fewkes, 1903.

69. Manangya Kachina Lizard Kachina

At Second Mesa, a green case mask with a yellow cen-
tral area. At Third Mesa, a brown case mask with a yel-
low central area. In both the masks there is a snout which
may or may not hold a lizard in its jaws. Kilt, sash, fox
skin, green moccasins. Body paint green and yellow. He
carries a rattle.

The Lizard Kachina is said to be of Zuñi origin and appeared first at
Hano in 1905, in a Mixed Kachina Dance. He is supposed to represent the
spirit of the turquoise lizard, *Crotophytus*.

70. Kahaila Turtle Kachina of Second Mesa

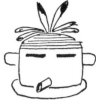

Copper green case mask; in place of hair, horizontal bands of all colors like a cap; tube mouth. Douglas fir or fur ruff, kilt, sash, fox skin, red moccasins. Sometimes wears a shirt, or may wear white body paint. He carries a rattle. Said to have first appeared at Shipaulovi in 1892, and said to be of Acoma origin.

71. Kwa Kachina Eagle Kachina

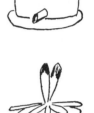

Green case mask with beak, inverted V painted in black over bill. Ruff: fur at Second Mesa, eagle feathers at Third Mesa. Kilt, sash, fox skin. Barefooted. Wings of eagle feathers on arms. Body painted black and yellow. This kachina sometimes appears with Mud Heads at night ceremonies in March.

Fewkes, 1903; Stephen, 1936.

72. Kisa Prairie Falcon Kachina, a Runner

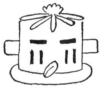

White case mask with two black warrior marks on cheeks. Ruff, fur or feathers. Breech clout, woman's belt. Wings on arms. Body painted white with yellow forearms and lower legs. He carries a yucca leaf whip to whip his victims. (See No. 47.)

Fewkes, 1903; Stephen, 1936.

73. Palakwai Red-tailed Hawk Kachina

Pink case mask with beak. At Second Mesa a nest is used on top of the head; at Third Mesa an inverted V over the beak. Ears of flicker feathers. Fur or feather ruff. Kilt, sash, fox skin, green moccasins (Second Mesa) or red (Third Mesa). Wings on arms. Appears in initiation years in the Bean Dance at Mishongnovi where he is a Mong (official) Kachina.

Voth, 1901; Fewkes, 1903.

74. Turposkwa Canyon Wren Kachina

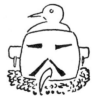

Green case mask, black inverted V over yellow beak. Feather ruff. Kilt, sash, woman's belt. Yellow leggings and green moccasins.

Fewkes, 1903.

75. Pawik Kachina Duck Kachina

Green case mask, with duck bill; right ear red, left ear a flower surrounded by red hair. Douglas fir ruff. Kilt, wedding sash, green moccasins. Body painted red with one green and one yellow shoulder. Carries a rattle and a staff.

Fewkes, 1903, 1923; Stephen, 1936.

76. Tocha Hummingbird Kachina

Green case mask with beak; top of head yellow. Douglas fir ruff. Kilt, sash, fox skin, and green moccasins. Bluish green body paint. Appears in Mixed Kachina Dance once in a long time.

Fewkes, 1903.

77. Yapa Mockingbird Kachina

White case mask with beak; over beak is inverted V made of corn husks and shells. Fox skin ruff. Kilt, sash, Carries bow and arrows and a rattle. Appears in Mixed fox skin, and green moccasins. Pinkish red body paint. Kachina Dance.

Fewkes, 1903.

78. Mongwa Great Horned Owl Kachina

Two types of masks: At First Mesa, a white case mask with beak, owl wings in place of ears. At Second and Third Mesas, a case mask covered with rabbit fur, "horns" of jackrabbit tails, beak. Fox skin ruff. Kilt, sash, fox skin, buckskin over back. White body paint. Carries a bow and a yucca whip. Appears in Mixed Kachina Dance, or in an ordinary kachina dance where he spies on the clowns. At First Mesa, he takes part in the Bean Dance and in the Water Serpent Ceremony.

Fewkes, 1903; Stephen, 1936.

79. Mongwa Wu-uti Owl Woman Kachina

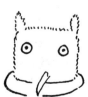

Case mask similar to No. 78. Woman's costume with ceremonial robe. Appears with her children, two or three little owls, who sing little songs in the night ceremonies after the Bean Dance.

Fewkes, 1903.

80. Hotsko Screech Owl Kachina

Gray case mask with beak, and rabbit tail "horns." Fox skin ruff. Rest of costume similar to No. 78. Carries a bow and arrows.

Fewkes, 1903.

81. Salap Mongwa Timber or Spruce Owl Kachina

Case mask covered with rabbit fur, rabbit tail "horns." Fox skin ruff. Kilt, sash, and green moccasins. Similar to No. 78.

Fewkes, 1903; Stephen, 1936.

82. Kowako Rooster Kachina

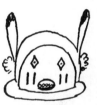

Blue case mask with red central portion and red beak, red feather cock's comb. Douglas fir ruff. Kilt, sash, fox skin, red moccasins. White, red, and yellow body paint. Carries a rattle. Appears in Water Serpent Ceremony sometimes.

Fewkes, 1903; Stephen, 1936.

83. Laqan Squirrel Kachina

Two types of brown case masks having a snout with teeth: Second Mesa, yellow band across eyes, which are green and rectangular, and red ears; Third Mesa, diamond shaped eyes, eagle feathers in place of ears, and parallel lines on cheeks representing foot-

Second Mesa

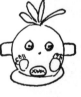

Third Mesa

prints of warrior. Kilt, sash, fox skin, green moccasins. Black body paint with yellow shoulders, forearms, and lower legs. Carries a rattle.

84. Tokoch Wildcat Kachina

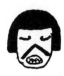

Black or white sack mask with red ears, snout with teeth, and pop eyes; cat track painted on cheeks. Wildcat skin ruff. Wildcat skin worn as shawl over back. White body paint. Carries rattle. Appears in Mixed Kachina Dance.

85. Toho Mountain Lion Kachina

Green face mask with black inverted V over snout. Breech clout, red hair skirt, green belt, and red moccasins. Yellow body paint. Carries rattle and bow and arrows. Appears in Mixed Kachina Dance.

Fewkes, 1903.

86. Kweo Wolf Kachina

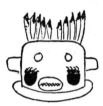

Brown case mask with pop eyes, snout with teeth, and wolf tracks painted on cheeks. Fox skin ruff. Costume similar to No. 85. Body painted yellow on back and white on front. Black or white spots on forearm and lower legs. Leans on a cane. Appears in Mixed Kachina Dance, and Water Serpent Ceremony at First Mesa.

Fewkes, 1894, 1903; Stephen, 1936.

87. Hon Kachina Bear Kachina

Case mask: At First and Second Mesas left side of face is rusty yellow, right side green, snout with teeth, bear tracks painted on cheeks. At Third Mesa mask may be:

Black mask, blue line below pop eyes, red streak on side, and blue bear tracks.

Yellow mask, blue line below pop eyes, red streak on side, and black bear tracks.

Blue mask, black line below pop eyes, red streak on side, and black bear track.

White masks, no pop eyes, no line below eyes but red line around eyes, black bear track.

At all Mesas wears: Fox skin ruff, breech clout, sash, red moccasins. A sheep skin, but formerly a bear skin, worn across shoulders. Brown body paint made from corn smut. Appears in Mixed Kachina Dance. Bear Kachinas are said to be very powerful and can heal the sick.

Stephen, 1936.

*88. Ursisimu

Unknown on Second and Third Mesas. Fewkes, 1903, Pl. XLIV.

89. Honan Kachina Badger Kachina

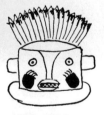

Case mask with red ears, snout, and badger tracks on cheeks. There are several types: white, green or black, and a new type with eagle feathers instead of red ears. Douglas fir or fur ruff . Kilt, sash, fox skin, maiden's shawl over shoulders, red moccasins. White body paint. Carries a rattle.

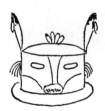

Second Mesa Third Mesa

Appears in Mixed Kachina Dances, and in the Water Serpent Ceremony at First Mesa. Stephen, 1936; Fewkes, 1903.

90. Chöf Kachina Antelope Kachina

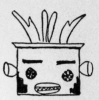

White case mask with antelope horns on top, blossoms for ears, and snout with teeth. Doulas fir ruff. Kilt, sash, fox skin, and green moccasins. Red and yellow body paint. Leans on a cane. One or two will sometimes appear in a Mixed Kachina Dance. Like all herbivorous animal kachinas, the Antelope Kachina is believed to bring rain and make the grass grow, so that there will be plenty of game. He is supposed to have power to cure spasms. Fewkes, 1894, 1903; Stephen, 1936.

91. Sowí-ing Kachina Deer Kachina

Green case mask with deer horns on top of head, blossoms for ears, and snout with teeth. Douglas fir or juniper ruff. Kilt, sash, fox skin, and red moccasins. Red and yellow body paint or may wear a velvet shirt instead. Leans on a cane. Is not often impersonated. Has power over rain and also spasms.

Fewkes, 1903; Earl and Kennard, 1938.

92. Pang Kachina Mountain Sheep Kachina

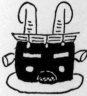

Black case mask with mountain sheep horns on top of head, blossoms for ears, and snout with teeth. Douglas fir ruff. Kilt, or maiden's shawl worn as a kilt, wedding sash, and red moccasins. White body paint or white shirt. Leans on a cane. Appears in bands in an ordinary kachina dance. Has power over rain and spasms like Nos. 90 and 91. Fewkes, 1894, 1903.

93. Mosairu Kachina Buffalo Kachina

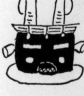

Usually wears face mask, painted green (First Mesa) or black (Second Mesa), with horns on side (First Mesa) or on top (Second Mesa), and a snout with teeth. Hair is black sheep skin with wool left on. Kilt, wedding sash,

First Mesa Second Mesa

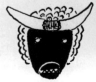

white trousers (formerly buckskin trousers), shirt, and red moccasins. Carries rattle and lightning stick. Appears in ordinary kachina dance.

Stephen, 1936.

94. Wakas Kachina Cow Kachina

White or green case mask with cow horns on top, red hair, cow ears or flower ears, and cow-like snout. Douglas fir ruff. Kilt, sash, fox skin, and red moccasins. Body paint can be any color to resemble that of a cow. Carries rattle and bow and arrows. Appears in ordinary kachina dances. Said to be a Zuñi kachina that first appeared at Oraibi in 1911, but known at First Mesa at the time Fewkes was there. Fewkes, 1903.

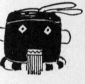

95. Suy-ang-e-vif Left-handed Kachina

Black case mask with diamond shaped eyes, mouth showing teeth, and a beard. Cloth or fur ruff. Breech clout, body covered with antelope, sheep, or goat skin, with hair on, red moccasins. Black horizontal stripes on lower legs and forearms. Carries bow in right hand, and a quiver full of arrows over left shoulder. Appears in ordinary kachina dances, in Mixed Kachina Dance, and separately as a warrior. He is supposed to have been derived from the Walapai Indians.

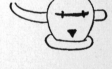

 Fewkes, 1903; Stephen, 1936; Earl and Kennard, 1938.

96. Wupá-ala Long-horned Kachina

Green sack mask, with upturned horn on right side and red ear on left side; eyes are Greek crosses joined, triangular mouth. Cloth ruff. Wears breech clout and red moccasins. Body painted white. Usually appears in Mixed Kachina Dance.

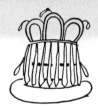

97. Tukwünag Cumulus Cloud Kachina

At First and Second Mesas, white case mask with cloud symbols on top. Third Mesa, no mask; feathers suspended from the headdress cover the face. Douglas fir ruff. Kilt, wedding belt, branches of Douglas fir hang from belt, bare feet. Body painted with a bluish sediment from the bottom of springs. Carries gourd filled with water in each hand. Appears in Mixed Kachina Dance and Hopi Salako Ceremony. Said to bring summer rain.

98. Tukwünag Kachin-mana
Cumulus Cloud Maiden

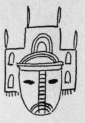

At First Mesa, a case mask, white on one side, brown on the other, with a tableta painted with cloud symbols. No ruff. Wedding robe, wedding sash, bare feet. Arms and legs painted with blue mud from springs. Carries a tray of cornmeal. Appears in Hopi Salako Ceremony.

Fewkes, 1903.

99. Nuvak-china Snow Kachina

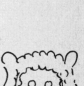

Blue case mask which may be painted in a variety of ways. May have a painted or a tube mouth. Douglas fir ruff. Kilt, sash, fox skin, and green moccasins. Body paint red, with one green and one yellow shoulder, unless kachina is draped with a woman's wedding robe and wedding sash. He carries a flute and a rattle.

Appears in Bean Dance, Water Serpent Ceremony, and Mixed Kachina Dance.

Fewkes, 1894, 1903; Stephen, 1936.

100. Nuvak-chin-mana Snow Kachina Maiden

White sack mask with a wig of white cotton wool, with maiden's whorls, and tube mouth. Cloth ruff. Woman's dress, maiden's shawl, and white buckskin boots. Carries and uses a rasp musical instrument. Appears in Snow Kachina Dance and sometimes in Niman Kachina Dance.

101. Horo Mana "Comb Hair Upwards" Maiden

White face mask with painted mouth showing teeth, red tongue hanging out, small beard, and red spot on each cheek. Fox fur ruff. Wedding robe, belt, and white moccasins. Carries a yucca hair-brush. Horo Mana appears with Nuvakchina (No. 99), and musses up people's hair.

Fewkes, 1903; Stephen, 1936.

102. Wukoqötö Big Head Kachina

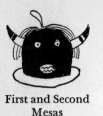

At First and Second Mesas, a black case mask with horns on the side of head, pop eyes, and raised mouth sometimes made from a gourd. Fox fur ruff.

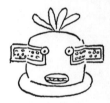

First and Second Mesas

Third Mesa, yellow (?) case mask, no horns, datura flower in place of one ear and vertical feathers in place of the other. Douglas fir ruff.

Third Mesa

On all Mesas wears kilt, sash, fox skin, and green moccasins. First and Second Mesas, body painted red with white vertical lines. Carries bow and arrows and a yucca whip. Third Mesa body painted black, red, and yellow. Carries rattle.

Wukoqötö appears in parade of the Bean Dance or in Mixed Kachina Dance. Is said to bring gentle rain without thunder. Sometimes selected for the Niman Kachina Dance. Voth 1901; Fewkes, 1903; Stephen, 1936.

103. Hólolo

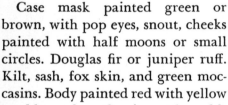

Case mask painted green or brown, with pop eyes, snout, cheeks painted with half moons or small circles. Douglas fir or juniper ruff. Kilt, sash, fox skin, and green moccasins. Body painted red with yellow shoulders, forearms and lower legs. Carries rattle and bow and arrows. Appears in kivas in spring or in Mixed Kachina Dance.

104. Ho-ó-te or Ahote

Black case mask, yellow on top of head, pop eyes, horns, and snout; star and moon painted in white on cheeks. Douglas fir ruff. Kilt, sash, fox skin, and red moccasins. Body painted red with yellow shoulders, forearms, and lower legs. Carries bow and arrows and rattle. Appears in Mixed Kachina Dance.

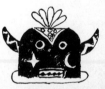

Voth, 1901; Fewkes, 1903; Earl and Kennard, 1938.

105. Hó-te

Yellow case mask with pop eyes, snout, and painted with red and yellow stars; Plains Indian feather headdress. Costume, body paint, and accessories similar to No. 104. Appears in regular kachina dance and Mixed Kachina Dance. Fewkes, 1903.

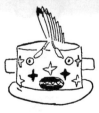

106. Lenang Flute Kachina

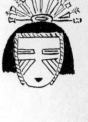

Green face mask with rectangular eyes, one blue and one yellow, triangular patches under eyes striped black and yellow, triangular mouth; flower headdress. Kilt, sash, fox skin, and green moccasins. Body paint red, one shoulder blue and one yellow, forearms yellow. Carries a flute and a sleigh bell. Appears in Mixed Kachina Dance.

Fewkes, 1903; Stephen, 1936.

107. Kwikwilyaqa Mocking Kachina

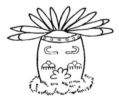

Brown case mask with juniper bark hair, tubular eyes and mouth painted with stripes, or may have snout. Three white lines under the eyes are the symbols. Black and white cloth ruff. Old shirt and trousers (white man's clothes), red moccasins. Carries rattle and cane. Appears in Mixed Kachina Dance and makes fun of everyone.

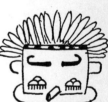

Fewkes, 1903; Earl and Kennard, 1938.

108. Talavai Kachina Early Morning Kachina

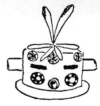

Green case mask with pothook eyes, usually has cloud symbols on cheeks, mouth may be tubular or painted. Douglas fir ruff. Kilt, sash, fox skin, and green moccasins. Body paint red, yellow, and blue-green. Talavai Kachina used to appear on house tops in the early morning and sing happy, sad, or critical songs.

Fewkes, 1903; Stephen, 1936.

109. Navuk-china Prickly Pear Cactus Kachina

Green case mask with circles representing flowers under the eyes, large tubular mouth. Douglas fir ruff. White shirt, kilt, sash, fox skin, and red moccasins. Body paint white if no shirt is worn. Carries a rattle and a staff with a cactus leaf tied at top. This is an old type of kachina which appears in Mixed Kachina Dance. (See No. 220.)

110. Ai Kachina Rattle Kachina

Second Mesa

Green or white case mask with painted flowers instead of ears. Douglas fir ruff. Kilt, sash, fox skin, and green moccasins. Carries a rattle. Is said to appear in the parade of the Bean Dance, Mixed Kachina Dance, and as a Runner. (See No. 47.)

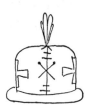

Third Mesa

111. Ota or Kwasa-itaqa Skirt Man

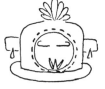

Second Mesa

Green or white case or face mask, with pothook eyes, and a single beak or a three-pointed upturned beak. Douglas fir ruff. Wedding robe worn if mask is white, woman's dress if mask is green, belt across chest and one shoulder, and green moccasins. Carries rattle. Appears in Mixed Kachina Dance.

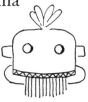

Third Mesa

112. Tutumsi or Komanchi Comanche Kachina

Green or yellow case mask with pop eyes, wide horizontal mouth and beard; Plains Indian headdress. Douglas fir ruff. Kilt, sash, fox skin, and red moccasins. Body painted red with yellow shoulders and forearms. Carries bow and arrows and rattle. Appears in Mixed Kachina Dance. Fewkes, 1903.

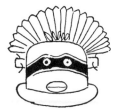

113. Hochani

Green case mask with black band across the eyes, built out mouth. Douglas fir ruff. Kilt, sash, fox skin, and red moccasins. Red body paint. Carries bow and arrows and a rattle. May appear in ordinary kachina dance or Mixed Kachina Dance. Fewkes, 1894, 1903.

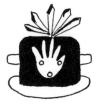

114. Sivu-i-qiltaqa Pot Carrier Man or Hand Kachina

Black case mask with a white hand outlined in red covering the case. Cloth or fox skin ruff. Kilt, sash, fox skin, hank of yarn over shoulder, and red moccasins. May wear white shirt or white body paint. Carries a pot on back, suspended by a tump line or from shoulders, and rattle. Appears in Mixed Kachina Dance and is said to be a Runner.

Fewkes, 1903 (Matia).

115. Maswik Kachina

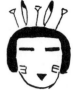

Green face mask with long hair, flower headdress, and triangular mouth. Kilt, sash, fox skin, green moccasins. Body painted brown with blood, yellow shoulders. A number of Maswik Kachinas appear together in a spring dance in initiation years, accompanying Masao into the plaza.

116. Maswik Kachin-mana Maswik Maiden

Green face mask with hair arranged in butterfly wing whorls with a flower in one whorl. White ceremonial robe over woman's dress, white boots or barefooted. Carries sacred water in a bowl. Accompanies Masao and Maswik Kachinas in the Masao Ceremony.

117. Salako Hopi Salako

White face mask with elaborate tableta with cloud symbols; chin painted with all colors radiating from center of red inverted U-shaped mouth. Body built up tall on a frame covered with eagle feathers and a wedding robe; green moccasins. No accessories. At a Salako ceremony, which is very rarely given, a male and a female figure take part. The dance was at Shungopovi in 1936, 1952, and 1957. Marionettes representing this kachina take part in Doll Dance.

Fewkes, 1894; Stephen, 1936.

118. Salako Mana Salako Maiden

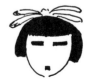

Similar in every way to Salako male (No. 117) except that Salako Maiden wears white boots.

Fewkes, 1894.

119. Poli Kachina Butterfly Kachina

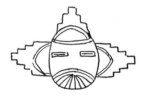

Blue face mask with rectangular eyes and a square mouth. Wears kilt, sash, woman's belt, and fox skin. Body painted red with one blue and one yellow shoulder. Carries rattle and flower. Appears in Butterfly Kachina Dance.

Earl and Kennard, 1938.

120. Polik Mana or Palhik Mana Butterfly Kachina Maiden

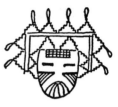

White face mask with triangular hachured areas or red spots on cheeks. Chin painted with lines radiating from the mouth, and each triangle so made is painted with a different color. Elaborate tableta. Costume may be a white, embroidered ceremonial robe and a kilt worn like a blouse, or a black dress and a maiden's shawl. The feet are usually bare and painted yellow.

Fewkes, 1903; Stephen, 1936; Earl and Kennard, 1938.

121. Saviki

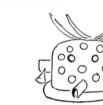

Brown case mask with painted snake carried in mouth. Fox skin ruff. White shirt, kilt, sash, fox skin, and red moccasins; hank of yarn worn across shoulder. Carries a cane and a ceremonial wand. An old type of First Mesa Kachina. Appears in the parade of the Bean Dance. Fewkes, 1903.

122. Avachhoya or Qá-ö Spotted Corn Kachina

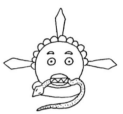

Zuñi or modern Hopi type wears case mask which may be any color of the cardinal points; eyes surrounded with a terraced area in white, tubular mouth. Four feathers form a horizontal cross on top of head.

New Type

Old Type

Douglas fir ruff. Breech clout, sash, and red moccasins. Body painted pink with white circles or white with pink circles. Old Hopi type wears black case mask with white circles painted all over it. Avachhoya is the younger brother of the Hemis Kachina, No. 132, and appears in Pamuya, and in regular kachina dances.

Fewkes, 1894, 1903; Stephen, 1936; Earl and Kennard, 1938.

123. Masao Kachina Earth God Kachina

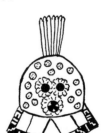

White case mask with protruding eyes and mouth made from rings of corn husks. Mask painted with small circles of all colors. Ruff is made out of a kilt fastened to back of mask. Rabbit skin blanket, sash, and red moccasins. Carries a rattle and yucca leaf whip. This kachina represents the spirit of the earth god. Masao Kachina does not live in the mountains

like the other kachinas, and can visit the Hopis at any time of the year. He often comes in August after the Niman Kachina, when the other kachinas have departed.

Fewkes, 1903; Stephen, 1936.

124. Masao Kachin-mana

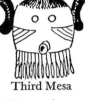

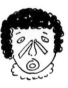

At Second Mesa, a white face mask with maiden's whorls. Woman's wedding costume. At Third Mesa, a mud colored case mask with tubular mouth, red hachured triangular area under eyes, and beard of bird feathers. Hair in maiden's whorls. Woman's costume with white boots. Carries a rasp musical instrument. She is supposed to bring much rain.

Second Mesa

Third Mesa

125. Huhuwa Cross-legged Kachina

White face mask with carved wooden nose, tubular mouth, or painted mouth. Wig made of lamb skin with wool left on. No distinctive costume. Wears shells around neck and carries a rattle. May take part in Bean Dance or regular kachina dance. Supposed to be the spirit of a Mishongnovi man, who probably had infantile paralysis in childhood. He speaks the Mishongnovi dialect and makes wisecracks, which Mishongnovi men are noted for. In the Bean Dance he gives presents to the children. See No. 203, Bluebird Snare Kachina.

Voth, 1901; Fewkes, 1903; Stephen, 1936.

126. Katoch Ang-ak-china Barefoot Long-haired Kachina

Green half mask, feather beard. Black line above beard with rectangular panels of all colors, long hair. Douglas fir ruff. Kilt, wedding sash, fox skin. Douglas fir anklets, bare feet, pink body paint. Carries a rattle. Appears in regular kachina dance.

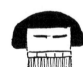

127. Ang-ak-china Long-haired Kachina

Green half mask with feather beard, black line over beard with rectangular panels of all colors, long hair. Kilt, sash, fox skin, green moccasins. Black and yellow body paint. Carries rattle and sprig of Douglas fir. Appears in regular kachina dance. (Similar to 126.)

Fewkes, 1903; Stephen, 1936; Earl and Kennard, 1938.

128. Ang-chin Mana or Qocha Mana White Corn Maiden

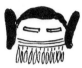

White half mask, feather beard, colored panels over beard, hair arranged in maiden's whorls. Woman's costume and maiden's shawl. Uses mano and metate. Appears with Long-haired Kachina, No. 127, and Duck Kachina, No. 75.

Fewkes, 1903; Stephen, 1936.

129. Takus Mana Yellow Corn Maiden

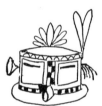

Yellow half mask, feather beard, colored rectangles above beard. Long hair hanging down back. Woman's costume and maiden's shawl. Uses mano and metate. Appears with Long-Haired Kachina, No. 127.

Fewkes, 1903.

130. Malo Kachina

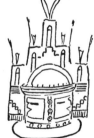

Case mask with one half face painted green and one half red, tubular mouth; no ears, blossom on one side and tuft of red hair and feathers on the other. Douglas fir ruff. Kilt, sash, fox skin, and green moccasins. Body painted any common kachina style. Carries staff tipped with feathers, and a rattle. Appears in regular kachina dance.

Fewkes, 1894, 1903; Stephen, 1936.

131. Niman Kachina Home Dance Kachina, A Class

The Niman Kachina Dance is an annual ceremony in July at most of the Hopi Pueblos. It is the last kachina dance of the year. It is said that any kachina may be selected as Niman Kachina, but the Hemis Kachina (No. 132) is usually selected and its name is synonymous with Niman Kachina.

132. Hemis Kachina Jemez Kachina

Case mask, of which half of the face is painted green and the other half pink, or it may be all white. Surmounted by an elaborate tableta painted with phallic and cloud symbols. Douglas fir ruff. Kilt, sash, woman's belt, fox skin, red moccasins. Hank of blue yarn across one shoulder and chest. Body painted in black corn smut with light colored half moons. Carries rattle and sprig of Douglas fir.

The Hemis Kachina is usually selected as the principal character in the Niman Kachina Dance and so is sometimes called the Niman Kachina. See No. 131 above.

Fewkes, 1894, 1903; Earl and Kennard, 1938.

133. Hemis Kachin-mana or Kachin-mana Kachina Maiden

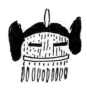

Yellow half mask with feather beard, parallel lines above beard; wig of red hair with maiden's whorls. Woman's dress, maiden's shawl and white boots. Carries a rasp musical instrument. This is the most common kachina maiden. She accompanies the Hemis Kachina as well as many others.

Earl and Kennard, 1938.

134. Tunei-nili Small River Kachina

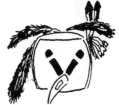

Purple case mask with a yellow beak, top and back of the mask is painted red. Eyes may be represented by drawings of ears of corn. No ruff. Red kilt and red moccasins. Body painted white with black lines. A kachina of Navajo origin said to mean "wash" or "small river." Appears with Navajo Kachina, No. 137.

135. Qoia or Kau-a Kachina

Old type: Green case mask with inverted V of red, black, and yellow over tube mouth, and horizontal band of same colors across forehead. In place of ears, bunches of cotton yarn similar to those used on Hopi wedding dresses. Douglas fir or juniper ruff. Red body paint with yellow shoulders, forearms, and lower legs.

Old Type

New Type

New type: Case mask with face half green and half reddish brown, divided vertically by a black line, tube mouth, half ovals of color under eyes, red on green side and green on red side.

Qoia is said to be an old time Navajo Kachina, and he sings in the Navajo language. Appears in a regular kachina dance. It is said that the last dance was held at Mishongnovi in 1914. Thought to be same kachina as Kau-a, No. 234.

Fewkes, 1903.

136. Qoia Kachin-mana

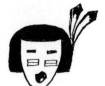

Green face mask with yellow and red patches under the eyes. Woman's dress, buckskin robe over shoulders, and white boots. Carries Navajo wedding basket. Accompanies Qoia Kachina.

Fewkes, 1903.

137. Tasaf Kachina Navajo Kachina

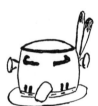

Green case mask, mouth a beak or tube, blossoms and tufts of red hair for ears, band of red yarn across forehead. Douglas fir ruff. Kilt, wedding sash, fox skin, red Navajo-style moccasins. Body paint pink and yellow. Carries a rattle. Appears in regular kachina dance.

Fewkes, 1903, Pl. XXXV, XXXVI, figures other Navajo Kachinas which have been taken from Navajo ceremonies and are said not to be Hopi. Fewkes, 1894, 1903; Earl and Kennard, 1938.

138. Tasaf Kachin-mana Navajo Kachina Maiden

Orange face mask with red cheeks, tube mouth, and Navajo woman's hairdress. Navajo woman's dress, red buckskin leggings and moccasins. Carries Douglas fir branches. Accompanies Navajo Kachina. Fewkes, 1903; Earl & Kennard, 1938.

139. Tasaf Yebitchai Kachina Navajo Talking God Kachina

First Mesa First Mesa Third Mesa

Case mask painted white with a green corn plant in place of a nose; eyes and mouth crescent shape or interlocking half-squares. Ears of corn painted on mask in place of ears. Fox skin or Douglas fir ruff. Wears a red kilt and goes barefoot, or wears a velvet shirt, trousers, leggings, and red moccasins, and lots of silver jewelry. Appears as a leader in the Navajo Kachina Dance. Fewkes, 1903.

140. Kipok Kachina War Kachina Leader

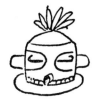

Brown case mask with green hour glass design in place of nose, tube mouth, red hair (Oraibi only). With or without abalone shell pendant on forehead. Cloth ruff. Shirt, white kilt, buckskin over shoulders, red moccasins. Body painted white, sometimes with black stripes. Carries a shield painted with special device—white circles on black ground, bow and arrows, and a yucca leaf whip. The kachina appears in pairs with the clowns at a kachina dance, and warns the clowns that they face impending disaster. Fewkes, 1903; Stephen, 1936.

141. Tuma-öi White Chin Kachina

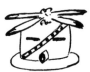

Face mask painted green, yellow, and red, with a white chin. Kilt, wedding sash, fox skin, and green moccasins. Red body paint with yellow shoulders, forearms, and lower legs. An old type of regular kachina. Reported to have last appeared in 1895 at Shipaulovi. Fewkes, 1903.

142. Kana Kachina Sunset Crater Kachina

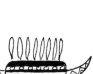

Case mask with half of face red and half yellow, colors being separated by a diagonal line; tube mouth. Douglas fir ruff. Wildcat skin robe or rabbit fur blanket, fox skin, and red moccasins. Occasionally a group of these kachinas appear in the evening and dance and throw baked corn to the spectators.

Sunset Crater near Flagstaff is sometimes called "Kana Kachinki" (Kana Kachina's House), as is also a rectangular rock on the west side of the mesa below Mishongnovi. Fewkes, 1903.

143. Konin Kachina Supai Kachina

White case mask with triangular mouth, chin painted radially in all colors (at First and Second Mesas) or with small squares of varied colors around mouth (Third Mesa). Horns at side of head. At Hano, a white face mask, with small coiled plaques in place of ears. No horns. Kilt, sash, fox skin, and red moccasins. Body painted white with red warrior marks, or one of the common kachina styles such as red and yellow. Carries bow and arrows and rattle. Appears in regular kachina dance.

First and Second Mesas

Third Mesa

Fewkes, 1894, 1903.

144. Tühavi Paralyzed Kachina

Black case mask with side horns turned down-ward, white spot on each cheek, green bird track on forehead, pop eyes, horizontal rectangular mouth, and beard. Fox skin ruff. Breech clout, fox skin, and red moccasins. Body painted black with white warrior tracks. Carries a bow and arrow.

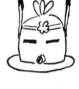

This kachina is depicted as paralyzed, and so may be carried by another kachina. In the story of this kachina, he has a blind companion, but the latter is never impersonated. Fewkes, 1903.

145. Kahaila Mad Kachina

Green case mask with red mouth built out, eagle tail feathers in place of ears. A hank of blue yarn is worn as band around head and across forehead. Douglas fir ruff. Kilt, sash, fox skin, green moccasins. Body painted black with yellow markings. Carries rattle. Kahaila is said to be a Rio Grande word (Keres or Tewa). Fewkes, 1894.

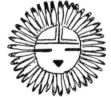

146. Tawa Kachina Sun Kachina

Yucca basket mask, with forehead red and yellow and lower part of face green, triangular mouth. Face completely surrounded by radiating eagle feathers. Fox skin ruff. Kilt, sash, fox skin, and green moccasins. Red body paint with one red shoulder and one green; forearms and lower legs green or yellow. Carries a flute and a rattle. Represents the spirit of the Sun God and appears in regular kachina dance. Fewkes, 1903.

147. Sohu Kachina Star Kachina

White case mask painted in various ways, stars on headdress. Buckskin shirt, sash, and fox skin. Body painted black with white shoulders and forearms. Appears in regular kachina dance. Fewkes, 1903.

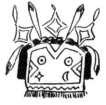

148. Na-ngasohu Kachina
Chasing Star or Planet Kachina

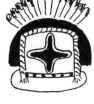

Case mask with face a four-pointed star, background may be black with a green star or green with a black star; Plains Indian headdress. Douglas fir or fox skin ruff. Cloth kilt of red-brown color, woman's belt. Red or black body paint with yellow shoulders, forearms, and lower legs. Carries a yucca whip and bell. Appears in pairs. Fewkes, 1903.

149. Navuk-china Cocklebur Kachina

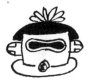

Pink case mask with center portion of face white; snout, and red ears. Douglas fir ruff. Kilt, sash, fox skin, red moccasins. Body painted red with yellow shoulders. Carries bow and arrows in left hand, cockleburs in the right.

Fewkes, 1903.

150. Pautiwa Zuñi Sun God

Green case mask with tube mouth, black painted eyes joined together. Douglas fir ruff. Kilt, wedding belt, fox skin, green moccasins; ceremonial robe worn as shawl. Body painted red with yellow shoulders, forearms, and lower legs. Appears at First Mesa in January at Pamuya. In 1900 he was the leader of this ceremony. He is a Zuñi solstice kachina.

Fewkes, 1894, 1903; Stevenson, 1904; Bunzel, 1932.

151. Cholawitze Zuñi Fire God

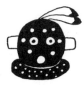

Case mask painted with black corn smut and spots of all colors, and tube mouth. Black ruff with colored spots. Breech clout, barefooted. Body painted black with corn smut and spots of all colors. Carries bow and arrows. A Zuñi kachina that appears in the Pamuya at First Mesa. (Similar to Hopi Kokosori, No. 9, at Second Mesa.)

Fewkes, 1903; Stevenson, 1904; Bunzel, 1932.

152. Sip-ikne Zuñi Warrior Kachina

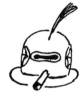

Case mask may be painted any one of the six directional colors, painted flower ears, tube mouth, eyes joined together as in Pautiwa (No. 150). Feather ruff. Kilt, ceremonial robe, fox skin, sash; barefooted. Body painted black with yellow shoulders. Carries yucca leaf whip and bow and arrows. A Zuñi kachina that appears in Bean Dance at First Mesa, and in regular kachina dance (?).

Fewkes, 1903; Stevenson, 1887, 1904; Bunzel, 1932; Earl and Kennard, 1938.

153. Hakto

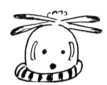

Green case mask, black dot eyes and mouth. Black and white cloth ruff. Buckskin kilt, sash, fox skin, and green moccasins. Carries deer antlers in both hands. A Zuñi Kachina that appears in Bean Dance at First Mesa.

Fewkes, 1894, 1903; Stevenson, 1904; Bunzel, 1932.

154. Sai-astasana or Hututu Zuñi Rain Priest of the North

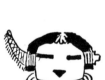

White case mask with horn on one side of head, and white terraced ear on the other; triangular mouth, rectangular black eyes. Black and white cloth ruff. Kilt, sash, woman's belt, fox skin, and buckskin over shoulders; red moccasins. Body painted white with small fine black spots. Carries bow and arrows. Appears in Bean Dance at First Mesa. Some say he emits a call like "Hu tu tu," and is known by that name.

Fewkes, 1903; Stevenson, 1904; Bunzel, 1932.

155. Sio Hemis Kachina Zuñi Jemez Kachina

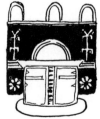

Case mask with face painted half red and half green; tableta with cloud symbols and flowers but no phallic symbols. Douglas fir ruff. Kilt, sash, woman's belt, fox skin, and red moccasins. Body paint black. Carries rattle and Douglas fir branches. Appears in regular kachina dance. Differs from Hemis Kachina (No. 132) in having no phallic symbols on tableta.

Fewkes, 1903; Stevenson, 1904.

156. Hoho Mana Zuñi Kachina Maiden

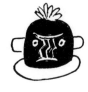

Black case mask with white eyes and white zigzag nose marks. Cloth ruff. Woman's dress, maiden's shawl; barefooted. A Zuñi kachin-mana who accompanies the Sio Hemis Kachina. In July, 1945, she accompanied the Hopi Hemis Kachina (No. 132) in the Niman Kachina Dance at Shungopovi.

Stevenson, 1904.

157. Sio Hemis Ta-amu Zuñi Kachina's Uncle

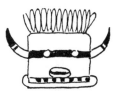

Green case mask with a single horn on top of head, black painted band across eyes, snout or tube mouth, flower ears. Douglas fir ruff. Ceremonial robe, and green moccasins. Appears with Hemis Kachinas and leads them. Said to appear at Pamuya at First Mesa.

Fewkes, 1903; Stevenson, 1904; Bunzel, 1932.

158. Sio Salako Zuñi Salako (Male)

Case mask painted green with black band across eyes, horns on side of head, and snout. Douglas fir ruff. Body built on tall frame about nine feet high (Hopi Salako, No. 117, is seven feet tall). Frame covered with eagle feathers and ceremonial robe. Green moccasins. Special Zuñi Salako Dance given at First Mesa on rare occasions. Fewkes witnessed one in July, 1900.

Fewkes, 1894, 1903; Stevenson, 1904.

159. Sio Salako Mana Zuñi Salako Maiden

Mask and costume similar to male Salako, except that the female figure wears white boots. Accompanies the Sio Salako male in special Salako Dance at First Mesa.

160. Chakwaina

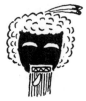

Black face mask with woolly lamb skin hair, half-moon shaped eyes, and red tongue hanging out of mouth. Buckskin or kachina kilt, sash, fox skin, and green moccasins. Body painted black with yellow shoulders, forearms, and lower legs. Carries rattle and bow and arrows. Appears in Pamuya at First Mesa. A Zuñi Kachina. Fewkes, 1894, 1903; Stevenson, 1904; Stephen, 1936; Wallis and Titiev, 1944.

161. Chakwaina Yu-adta Chakwaina's Mother

Black case mask, diamond shaped eyes, white mouth, red beard. Woman's costume, black shawl with white crosses, red moccasins. Carries rattle and bow and arrows. Yu-adta is said to be a Tewa name.

Fewkes, 1903; Wallis and Titiev, 1944.

162. Chakwaina Sho-adta Chakwaina's Grandmother

Black case mask with red tongue hanging out of mouth, hair arranged in maiden's whorl on one side of head, and hanging down on the other. Woman's old dress, wedding belt. Appears in Pamuya at First Mesa.

Her story, which explains the single maiden's whorl, is similar to that of Hé-é-e (No. 21). Stephen, 1936.

163. Chakwaina Mana Chakwaina Maiden

Similar in every way to No. 162, and probably represents the same individual. Story similar to that of Hé-é-e (No. 21).

Fewkes, 1903; Stephen, 1936.

164. Ahaoloni or Ahülani First Mesa Solstice Kachina

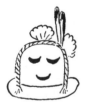

Even Numbered
Years

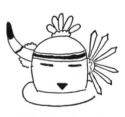

Odd Numbered
Years

Appears in two forms at Walpi: In odd numbered years (Snake Dance years), the mask is a green case mask with a single horn on one side of the head and a fan-shaped ornament on the other; rectangular eyes and triangular mouth. In the even numbered years (Flute Dance years), the mask is a green case mask with crescent-shaped eyes and mouth, and the face is bounded by a roll of twisted yarn of several colors.

Both forms of Ahaolani have a wildcat skin ruff, and wear a white shirt, kilt, sash, woman's belt, fox skin, knitted leggings, and green moccasins. Both carry a ceremonial staff and a gourd of water. The name refers to the opening phrase of his song, which means "return," as he is the first kachina to return in the December Solstice Ceremony at First Mesa. Fewkes thinks he may be the same as Ahöla, No. 2.

Fewkes, 1903; Stephen, 1936.

165. Sakwap Mana Blue Corn Maiden

Mask and costume similar to Yellow Corn Maiden (No. 129). The only difference is that she carries a basket of blue corn. Appears in Solstice Ceremony at First Mesa.

Fewkes, 1903.

166. Sio Avachhoya Zuñi Corn Kachina

Black case mask with tube mouth painted red, eyes painted like flowers; blue flower on one side of head for ear, tuft of red hair and feathers on the other. Feather ruff. Kilt and green moccasins. Red body paint with yellow shoulders, forearms, and lower legs. Appears at Pamuya at First Mesa.

Fewkes, 1903; Stevenson, 1904.

167. Chiwap Sand Kachina

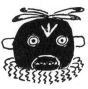

At First Mesa, it wears black case mask with green bird track on forehead, snout, red ears, and pop eyes. Black corn husk ruff. Black kilt, red moccasins. Carries deer antlers in hands. At Third Mesa, the figure is said not to wear a mask.

Fewkes, 1903; Stephen, 1936.

168. Pahi-ala Three-horned Kachina

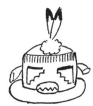

White case mask with curved black band under pop eyes, snout with teeth, and three straight horns on top of head. Douglas fir ruff. Kilt, sash, fox skin, green moccasins. Body painted red with yellow shoulders, forearms, and lower legs. Said to be a Zuñi kachina introduced to First Mesa in 1921.

169. A Kwivi Kachina A Proud Kachina

White or pink case mask with black or green terraced areas under the eyes, flower ears, snout with teeth. Douglas fir ruff. Kilt of any bright colored material, fox skin, no sash, red moccasins. White body paint. Carries rattle and bow and arrows. Appears in regular kachina dance. This is said to be a Zuñi type introduced at Mishongnovi in 1899. This kachina probably has another more specific name.

Kwivi seems to be a class of kachinas rather than a type. The mask characters are said to change frequently. The principal characteristic of the Kwivi Kachina appears to be that they wear lots of ornaments. See also No. 180.

170. Marao Kachina

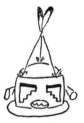

Case mask painted in a variety of ways, snout with teeth, flower ears; tripod headdress similar to that worn by women in the Marao Ceremony. Douglas fir ruff. Kilt, sash, fox skin, red moccasins. White body paint. Carries rattle. Said to be a Zuñi type, not yet well fixed and quite variable. Introduced at Walpi in 1920. Appears in regular kachina dance.

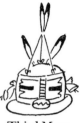

Second Mesa

Third Mesa

171. Navan Kachina Velvet Shirt Kachina

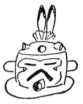

Pink or green case mask, tube mouth, inverted V over mouth. Four flowers on head. Douglas fir ruff. Velvet shirt, kilt, sash, fox skin, red moccasins. White body paint. Carries rattle and bow and arrow. Appears in regular kachina dance. Said to be a Zuñi type introduced after 1900. Earl and Kennard, 1938.

172. Movitkuntaqa Yucca Skirt Man
or Yucca Kachina

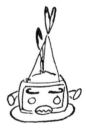

Green case mask with pot hook eyes, white spot representing the footprint of an animal under the eyes, snout with teeth, flower ears; tripod headdress. Douglas fir ruff. Kilt hung with yucca leaves, fox skin, red moccasins. Body not painted. Carries rattle and bow and arrows.

It is said that Tewakwaptewa, the Oraibi chief, dreamed of the Kachina. First danced at Oraibi in 1934. Brings cold weather. When danced at Moenkopi, the peach blossoms froze. The author saw it given at Oraibi in a sleet storm. Earl and Kennard, 1938.

173. Korosto

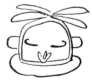

Green case mask with a three-pointed white beak or snout in place of mouth, pothook eyes. Douglas fir ruff. Ceremonial robe, felt roll across chest, green moccasins. Carries a rattle and a skin pouch filled with sacred corn meal. Said to be a Keresan kachina from New Mexico.

Fewkes, 1903; Stephen, 1936.

174. Piokot

Case mask painted green (First Mesa) or brown (Oraibi). Red device on cheek at First Mesa, absent at Oraibi. Flower on forehead. Douglas fir ruff. White shirt, black kilt, woman's belt, red moccasins. Carries rattle and bow and arrows. Fewkes, 1903.

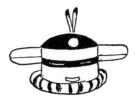

175. Hututu

Fewkes' drawing may be same kachina as Sai-astasana (No. 154). Fewkes, 1903, Pl. III; Stevenson, 1904; Bunzel, 1932.

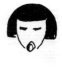

176. Samawutaqa

Maroon-brown face mask, tube mouth, natural hair. Shirt and trousers, originally buckskin, red moccasins. Carries rattle and a burden basket, supported by tump line, on back. Appears in Mixed Kachina Dance. This is said to be the only kachina that the Tewa people brought with them from the Rio Grande to Hano about 1700.
Fewkes, 1903.

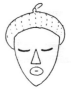

177. Loi-isa

Brown face mask, carved wooden nose, built up mouth, cloth headdress. Shirt, breech clout, green moccasins. Said to have been introduced from Acoma or a Rio Grande Pueblo.
Fewkes, 1903; Stephen, 1936.

178. Kwavonakwa A Kachina Maiden

Similar to Hemis Kachin-mana (No. 133). Appears in Bean Dance Parade at Second Mesa. An important kachina mana at Second Mesa.

179. Kahaila Kachin-mana Turtle Kachina Maiden

Green face mask, red and yellow parallel vertical lines on cheeks. Hair in two knots at back of head. Wears a Rio Grande woman's dress. The kachina is supposed to have come from Acoma. Appears in the Turtle Kachina Dance, see No. 70. Do not confuse with Kahaila, the Mad Kachina, No. 145.

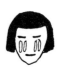

180. Pö-ökang Kwivi Kachina
Proud War God Kachina

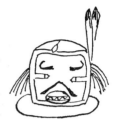

White case mask with snout, inverted black V over snout. Douglas fir or juniper ruff. Kilt, sash, fox skin, black knit leggings, red garters, red moccasins. Body painted black with four pairs of white vertical "warrior's foot prints."

181. Kavai-i Kachina Horse Kachina

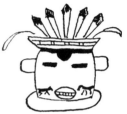

White case mask with red ears, snout with teeth, a picture of a horse painted on each cheek. Ruff? Kilt, sash, etc., red moccasins. Body painted red with one green and one yellow shoulder.

182. Tsil Kachina Chili Pepper Kachina

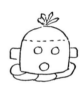

Yellow case mask with large round eyes, bunch of chili peppers on top of head. Old rag for ruff. Breech clout. Carries a yucca leaf whip. A Wawarus or Runner (see No. 47). Reported from Second Mesa.

183. Kwitanonoa A Runner

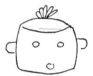

Brown case mask with large round eyes. Old rag ruff. Breech clout. Body painted red. Carries a yucca leaf whip. A Wawarus or Runner (see No. 47 and No. 247). Reported from Second Mesa.

184. Sakwats Mana A Runner Maiden

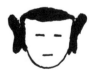

White face mask, hair in maiden's whorls. Maiden's shawl and dress. Barefooted. Carries a yucca leaf whip. Accompanies Wawarus or Runners (No. 47), at Second Mesa.

185. Hilili

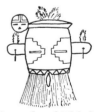

Case mask with face divided diagonally, painted brown on one side and blue on the other; mouth a horizontal line, with beard. Often with a sun symbol attached to rim of mask.

First Mesa

Second and Third Mesas

Ruff a wildcat skin with paws. Kilt, sash, fox skin, red moccasins. Body painted red with white spots. Carries a yucca leaf whip and bells. Said to come from Zuñi or from Laguna. Appears in numbers with Mud Head Clowns who sing; Hilili remains silent. The Hilili Kachina Dance is sometimes called a "Witchcraft Dance," *i. e.*, against witchcraft.

Another form of Hilili appears in the Pamuya at First Mesa and is said to be of Zuñi origin.

Fewkes, 1903; Bunzel, 1932; Stephen, 1936.

186. Hototo

At First Mesa: Pink case mask with black band across the eyes, which are pop eyes, horizontal mouth, and beard. Wildcat skin ruff. Buckskin shawl, kilt, sash, woman's belt, fox skin, and red buckskin leggings and moccasins. Carries rattle in right hand; bow and yucca whip in left; quiver on back.

At Second Mesa: Case mask with half the face painted green and half brown, divided by a vertical center line; bear track on each cheek, and a snout with teeth; horns in place of ears. Rest of costume same as at

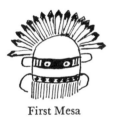 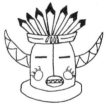

First Mesa.

Appears at First and Second Mesas in Bean Dance Parade, and in Mixed Kachina Dance. He is said to order Hopis to gather wood for the kiva fire. Fewkes, 1903.

First Mesa Second Mesa

187. Rügan Rasp Kachina (a class)

A class of male kachinas that come in groups, accompanied by the Corn Maidens, who play on rasp musical instruments. There are said to be various types who have the same songs but my informants could not name or describe them all. The feather headdress made of four eagle feathers, two projecting horizontally above each ear, seems to be characteristic of all kachinas called Rügan. See 188, 238, 239, 240, 241, 242.

188. Muzribi Bean Kachina (A Rügan Kachina)

Green case mask with a red tube mouth; on either side of the face are spirals representing germinating bean plants. Juniper ruff. Regular kachina costume and body paint.

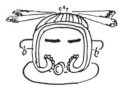

Fewkes, 1903.

189. Söhönasomtaqa "Man with Reeds Tied To"

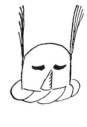

Case mask (color not indicated) with upturned beak
made of corn husks, tufts of reeds on side of head in place
of ears. Woman's dress, wedding sash, and white boots.
Carries bow, and quiver on back. Appears at the Parade of
Bean Dance and in Mixed Kachina Dance, and at the clean-
ing out of the springs. Reported from Third Mesa.
 Voth, 1901.

*190. Gyarz or Kyaro or Kyash Kachina Parrot Kachina

Face mask (color not indicated) with parrot heads painted below eyes.
Stephen (1936) reported that two appeared with Hano Clowns.

191. Hano Mana or Hokyana Mana Hano Long-haired Kachina Maiden

Green face mask with hair dressed in Tewa fashion.
Woman's dress, ceremonial robe, maiden's shawl, and white
boots. Appears with Long Hair Kachina at Hano. Some-
times acts as drummer. Stephen, 1936.

192. Hapóta

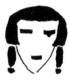

Pink face mask with carved wooden nose. Stephen (1936) re-
ports that he plays drum at Hano.

193. Hishab Kachina Mormon Tea (Ephedra) Kachina

Green case mask covered with white dots, with flower
in place of right eye; tufts of red hair in place of ears
and eagle feathers projecting upward from one tuft and
parakeet feathers from other; tube mouth. Appeared in
Bean Dance at First Mesa according to Stephen, 1936.

194. Mashanta Flower Kachina

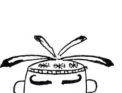

Green case mask with cloud symbols under the
eyes; stars on top of head and sun symbol on back
of head. Regular Kachina costume and body paint.
Mask has some similarities to variants of No. 46.
 Stephen, 1936.

*195. Lemowa Hail Kachina

Mentioned by Stephen (1936, p. 1143) as taking part in the Winter Solstice Ceremony at First Mesa. Said to live at Lakonabva, a spring on the west side of the San Francisco Mountains (Leroux Spring ?). No description.

196. Kawaika Kachina A Santo Domingo Kachina

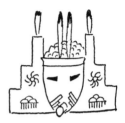

Green face mask with tableta, each side of face painted in cloud symbols. Kilt, woman's belt, fox skin, and green moccasins. Body painted red with yellow shoulders, forearms, and lower legs. Carries sleigh bells and white gourd rattle. Said to be the same as the Turwi Kachina at Santo Domingo. Appears with the Long-haired Kachinas and at the Zuñi Salako at First Mesa. Fewkes, 1894; Stephen, 1936.

197. Pash Kachina Field Kachina

White or green face mask, tube mouth, Hopi-style hairdress, horizontal zigzag lines on left cheek in all colors, horizontal bands of color on right cheek in red, blue, and yellow. Wears velvet shirt, white split trousers, leggings, and red moccasins.

198. Owa-ngaroro Mad or Stone Eater Kachina

 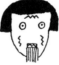 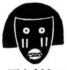

First Mesa Second Mesa Third Mesa

(1) White face mask, snout, horns, red hair mussed up. (First Mesa) Fewkes, 1903.

(2) White face mask with painted mouth, beard, and black vertical zigzags on cheeks (Second Mesa); or

(3) Black face mask with a snout, and white warrior marks on cheeks (Third Mesa).

All have pop eyes and lots of red hair. An old blanket serves as a kilt. Body painted with white shoulders and white circles on chest. Carry a yucca leaf whip, bow, and arrows. An old type of kachina that appeared in regular kachina dances, and in Bean Dances at First Mesa. The last Owa-ngaroro Kachina dances took place at Shungopovi in 1909, and at Oraibi in 1910 or 1912. It is unknown to the younger generation of Hopis.

The masks reported from the three mesas are so different it is not certain that we are dealing with one kachina. Stephen, 1936.

*199. Nüitiwa Thrower Kachina

Appeared in the "Wet-running" Kachina Dance at Hano, according to Stephen (1936). No description or illustration. Carries a new wash basin.

200. Nahó-ilé-chiwa-kopá-choki Kachina
Cross Crown Kachina

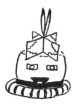

Green case mask with pop eyes, triangular mouth. Vertical crossed shingles on top of head said to refer to the points of the compass. Douglas fir or cloth ruff. Regular kachina costume and body paint. Stephen, 1936.

201. Wukoqala Big Forehead Kachina

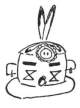

Brown case mask with blue lines about eyes, hour glass in white under each eye. Kilt, sash, woman's belt, and red moccasins. Woman's belt over one shoulder. Carries rattle and rabbit stick. Appeared in Mixed Kachina Dance, but is an old Oraibi type not seen any more. He asks boys to go out and be good hunters.

202. Ewiro Warrior Kachina

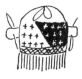

Case mask with face divided by a diagonal line, half face being white with black stars and the other black with white stars; long horizontal mouth, and beard. An old type of Third Mesa kachina.

203. Choshurhurwa Bluebird Snare Kachina

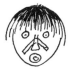

White face mask with carved nose, with inverted V across nose, stringy gray hair. Old ragged blanket. Reported by Stephen (1936) to have taken part in Bean Dance at First Mesa. This kachina resembles No. 125, Huhuwa, the Cross-Legged Kachina, more than any other and the name is somewhat similar. Fewkes, 1903; Voth, 1901; Stephen, 1936.

204. Üshe or Ütse Hano Cactus or Cholla Cactus
Kachina

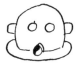

Sack mask painted white or green, with red ears and tube mouth. Ruff (?). Rabbit skin blanket about waist, and red moccasins with fringe. He carries in his hand some piki bread, in which is hidden a piece of cholla cactus, and offers it to unsuspecting people. Navajo call him Hush-yei or Chaschin-yei. He is a clown who appears with the Mud Heads at Hano. Stephen, 1936.

205. Yoche Apache Kachina

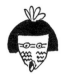

White face mask with red band across eyes, horizontal zig-zags in red, yellow, and green under the eyes. A calico breech clout so long it almost touches the ground. Red body paint.

Stephen, 1936.

206. Patszro Snipe Kachina

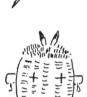

Green case mask with bird painted on forehead, rainbows on sides of head, red beak and red ears. Black breech clout. Body painted white and small feathers are stuck on with gum at intervals.

Fewkes, 1903.

207. Hospoa Road Runner Kachina

Green case mask covered with rows of black and white crescents, red ears, and red beak. Kilt, sash, woman's belt, fox skin, and green moccasins. Red and yellow body paint. Carries a flute in one hand and a rattle in the other. Fewkes (1903) reports that this kachina had on its back a "moisture tablet"—a painted skin stretched over a framework.

*208. Koyona Turkey Kachina

Green case mask with long beak and red wattles made of flannel cloth. Body painted white with small feathers attached with gum. Green moccasins.

Fewkes, 1903.

*209. Mulutatkia A Zuñi Kachina

Fewkes, 1903, Pl. XLV; Stevenson, 1904.

*210. Zuñi Jemez Kachina

A variant of No. 155.
Fewkes, 1903, Pl. XLV.

*211. Situlilü Zuñi Rattlesnake Kachina

Said to be a Zuñi kachina but not on Zuñi list. Wears a Hopi snake dancer's kilt.

Fewkes, 1903, Pl. LXVI.

*212. Teuk

Said to be a Zuñi kachina but not recognized on Zuñi list.
Fewkes, 1903, Pl. XLVI.

*213. Pakwabi

Said to be a Zuñi kachina, but not on Zuñi list.
Fewkes, 1903, Pl. XLVI.

214. Kwasus Alektaqa

Green case mask with red back, upright eagle feathers
resembling horns on sides of head in place of ears, tube
mouth.
Fewkes, 1903, Pl. XLVII.

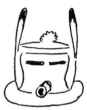

215. Alo Mana

White half mask with feather beard. Woman's dress,
and maiden's shawl, white boots. Said to accompany
No. 214.
Fewkes, 1903, Pl. XVII.

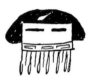

*216. Old Kachina Clan mask

Fewkes, 1903, Pl. XLVII.

*217. Old Hanau Clan mask

Fewkes, 1903, Pl. XLVIII.

218. Pohaha (Hano) or Nalwc-ala (Hopi) Four-horned Kachina

Case mask with half face painted green and half
brown, horizontal mouth with black beard; four horns
on top of head. Skin worn over one shoulder, white
trousers, red moccasins. Blue body paint. Carries rattle
and bow and arrows. A Hano kachina.
Fewkes, 1903, Pl. XLVIII.

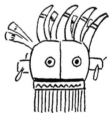

*219. Hopinyu (?)

Yucca basket mask with upper half of face divided by vertical black line
into green quarter and white quarter, each with black stars; bottom half
of face red, with beak. Douglas fir ruff. Kilt, sash, woman's belt, fox skin.
Red body paint with one yellow and one green shoulder. Carries branch
of Douglas fir and bow and arrows. This kachina is said to have come from
Sikyatki.
Fewkes, 1903.

220. Yunya Prickly Pear Cactus Kachina

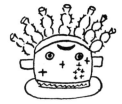

White case mask with black crescent moon and stars, horizontal mouth; prickly pear cactus with fruits on head. Douglas fir ruff. Kilt, sash, and green moccasins. Red body paint, with white shoulders and forearms covered with stars. Carries yucca leaf switch and bow and arrows. A First Mesa kachina. See No. 109.

Fewkes, 1903.

221. Yunya Mana Prickly Pear Cactus Maiden

White case mask with warrior marks on cheeks, triangular mouth. Hair done in maiden whorls. Woman's dress, maiden's shawl, woman's belt, and white boots. Carries a basket of cactus fruit.

Fewkes, 1903.

*222. Makto Rabbit Stick Kachina

Old mask at First Mesa.
Fewkes, 1903, Pl. XLIX.

*223. Pakiowik Fish Kachina

Old mask at First Mesa.
Fewkes, 1903, Pl. LXII.

*224. Ketowa Bisena

Old mask at First Mesa.
Fewkes, 1903, Pl. LXII.

*225. Patun Kachina Squash Kachina

Said to be a Wawarus, a Runner.
Fewkes, 1903, Pl. LII.

*226. Qá-ö or Ká-e Corn Kachina

This may be a variant of No. 122.
Fewkes, 1903, Pl. XXXVI.

*227. Paski Kachina Hoe Kachina

White face mask, with red on cheeks. Black breech clout, fox skin, and maiden's shawl over one shoulder. Carries a modern hoe.

Fewkes, 1903, Pl. LII.

***228. Old Mask at Walpi Called "Wiki's Kachina"**
Fewkes, 1903, Pl. LXVII.

***229. Tiwenu**
Fewkes, 1903, Pl. XL.

***230. Old Mask**
Fewkes, 1897, Pl. CVIII.

***231. Kuwan**
See Ahaolani, No. 164.
Fewkes, 1903, Pl. VIII.

***232. Kau**
See No. 14, Hu Kachina, and No. 94, Cow Kachina.
Fewkes, 1903, Pl. XXXIX.

***233. Palölökon Kachina Plumed Serpent Kachina**
Green case mask, horizontal slit eyes, tube mouth (?). Plumed serpents painted on each cheek, datura flower ears. Douglas fir ruff. Kilt, sash, woman's belt, fox skin. Body painted red with green and yellow shoulders and forearms. Carries a wand with a star on the end. Fewkes, 1903, Pl. XL, calls it Nuvak Kachina.

234. Kau-a Kachina (See No. 135, Qoia Kachina)

235. Na-uikuitaqa "Peeping Out Man"
Green case mask with red ears, tube mouth, and rectangles under eyes. Douglas fir or juniper ruff. Kilt, wedding sash, green moccasins. Red body paint with yellow shoulders, forearms, and lower legs. Seen by an informant at a night dance in Hotevilla in 1943.

236. Möna Kachina River or Thunder Kachina
Green case mask, triangular mouth, a band across the forehead. Fur ruff. Kilt, sash, woman's belt, red moccasins. Bluish body paint. Appears singly in Mixed Kachina Dances. Third Mesa.

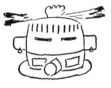

237. Umtoinaqa "Making Thunder" Kachina

Green case mask, triangular mouth, yellow and red bands across the forehead, warrior marks on the cheeks. Fox skin ruff. Kilt, sash, red moccasins with fringe. Body painted blue with red forearms. He carries a bull roarer and wears strings of shells across his chest. He is said to appear singly in Mixed Kachina Dances.

238. Rügan A Rasp Kachina

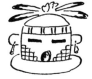

Green case mask with cheeks terraced in squares of various colors, black and white band across forehead, tube mouth. Juniper ruff. Kilt, wedding sash, woman's belt, hank of black yarn across shoulder, green moccasins. Carries juniper branch in right hand, rattle in left. Body painted red with yellow shoulders.

239. Rügan B Rasp Kachina

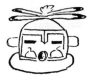

White case mask with red and yellow corn symbols on cheeks, blue and red border to face, tube mouth. Costume same as above.

240. Rügan C Rasp Kachina

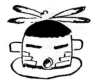

Green case mask with red, yellow, and white terraced elements on cheeks. Costume same as above.

241. Rügan D Rasp Kachina

Green case mask with red tube mouth. Douglas fir ruff. Costume as in A. Red body paint with one green and one yellow shoulder.

Called Hokyana by Fewkes, 1903, Pl. XXXIII. Hokyana is the name of the Hano Long-haired Kachina which fits Fewkes' description but not the illustration.

242. Rügan E Rasp Kachina

Green case mask with diagonal bands of red, yellow, and blue across the face. Costume similar to D. Called "Keme" by Fewkes, 1903, Pl. XXXVIII.

243. Tumoala Devilsclaw Kachina

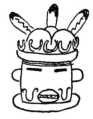

Green case mask, snout, red ears. On the rim of helmet
a row of seed pods of *Martynia louisiana*, called Devilsclaw.
Cloud symbols, cut out of wood, on top of head. Devilsclaws
painted on cheeks, red and yellow stripe above eyes under
visor. Juniper ruff. Costume and body paint similar to
Powamui Kachina, No. 38. This kachina appears in Mixed
Kachina Dances and is supposed to catch the rain clouds with the claws
and draw them from distant places to the Hopi Mesas.

244. Kuwantotim A Singer

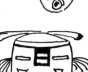

White face mask, tube mouth, inverted V over mouth, rec-
tangular eyes. White costume; kilt and shirt.

245. Nihiyo

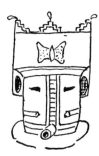

White case mask, snout, rectangular eyes. Hour glass
symbol on cheeks, white kilt, with eagle feathers pendant
from waist. White body paint with black horizontal lines
across chest. Appears in Mixed Kachina Dance.

246. Poli Sio Hemis Kachina
Butterfly Zuñi Jemez Kachina

Green case mask (?), tableta similar to Hemis Ka-
china but with butterfly painted on it as well as corn
symbols. Details of mask much like Hemis Kachina
except for the addition of a tube mouth. White kilt,
sash, etc. White body paint. Ordinary kachina dance.

247. Kwitanonoa Dung Carrier

Black case mask with white bands across the eyes and mouth, small red
ears. No costume. Black body paint. This kachina is a Wawarus or
Runner who smears human dung on the face of his victim, if he can
catch him. (See No. 183).

248. Owaq Kachina Coal Kachina

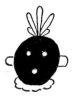

Black sack mask with white eyes and mouth. Rag ruff.
Kilt is made from woman's old dress. Fox skin and red moc-
casins. Black body paint. Carries a rattle. This is an old type
of kachina and does not appear any more. Said to have last
appeared in Mishongnovi in 1899.

Fewkes, 1903; Stephen, 1936.

249. Tasaf Kachina A Navajo God Kachina (Naastadji, the Fringe Mouth God)

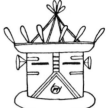

Case mask, half green and half red, divided by a vertical band of black and white in the center of the face. Tripod headdress with a visor. Flower ears. Douglas fir ruff. Kilt, and green moccasins. Body is painted with a network of red lines. Carries Douglas fir branches.

Fewkes, 1903.

250. Tawa Koyung Kachina Peacock (Sun Turkey) Kachina

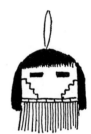

Blue case mask with white face set off with red and black lines, rectangular eyes, black beak, red ears. Wears a regular kachina costume. Body painted red with yellow and blue shoulders.

251. Tasaf Anya Navajo Long-hair Kachina

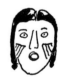

Half mask painted green with yellow terraced elements on cheeks. White body paint with yellow shoulders, forearms, and lower legs.

252. Piptu Wu-uti

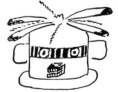

Face mask with nose, and triangular areas of cross hachures under the eyes. Woman's hairdress and costume. Kachina is said to be the female companion of Piptuka, No. 61, a clown.

253. Sikya-chantaka Flowers or Guts in the Snow

Green case mask, black band with white squares across the eyes, band outlined with red; pop eyes, red ears, mouth square with painted teeth (may or may not be built out), white feathers on top of head. Kilt, sash, green moccasins. Body painted red with yellow shoulders, forearms, and legs. There seem to be some other masks which are quite different, called Sikya-chantaka by one informant. Because of a difference of opinion I have omitted these variations until they can be further checked.

254. Motsin Dishevelled Kachina

Case mask, face painted black, outlined with two white lines, rectangular mouth with beard, red ears. Headdress, a sheepskin wig with long hair that is mussed up. The eyes are distinctive and separate him from the Left-handed Kachina, No. 95, which he resembles. His costume nowadays is a shirt and pants. He carries bow and arrow and a whip. His function is to enforce attendance in community work parties, such as cleaning of the springs, and he takes part in some ceremonies.

255. Yo-we (Named for sound the kachina makes)

Brown case mask, pop eyes, blue warrior marks on cheeks. Ruff of skin. Black breech clout, sash, bandoleer, red moccasins with fringe, bobcat or rabbit skin robe. Body paint white with a brown patch in area of ribs. Carries a staff, and wears turtle shell rattle on each leg. Yo-we appears at Bean Dance on Third Mesa. He is said never to take part in Mixed Kachina dances. Belongs to the Pumpkin clan.

King, 1949.

256. Homahtoi Kachina Angry Kachina

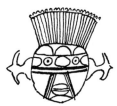

Sack mask basically green with red, black and green horizontal lines under the eyes; diagonal lines of same colors on each side of mouth. Pop eyes, red ears shaped like a flower, snout with teeth. Red, green, and white cloud symbols on blue background over eyes. Kilt and sash; body paint, red with yellow shoulders. Carries rattle in right hand, bow and arrows in left. Appears in Mixed Kachina Dances.

257. Poko Kachina Dog Kachina

Appears in various forms, sometimes with a carved head, sometimes a sack mask. Snout usually yellow. The most characteristic symbol is five or more dots on each cheek. Poko acts as a clown on First and Second Mesas. The Dog Kachina is supposed to represent the spirit of all domestic animals. Huhuwa, No. 125, is his uncle; the Sun Chief, No. 146, his father; and Hahai-i Wu-uti, No. 44, his mother.

Stephen, 1936, Pl. XVI, p. 562.

258. Tuskiapaya Crazy Rattle Kachina

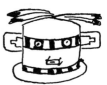

Case mask painted green or blue, pop eyes, rectangular mouth, usually built out. Band of alternating black and white squares across eyes. Ears with stepped element in white. Kilt and sash; body paint, red with yellow shoulders.

259. White Cloud Clown

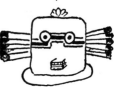

Sack mask painted white, built out nose, realistic mouth, red spots on cheeks. Wears black breech clout and white body paint.

260. Holi (Named for sound the kachina makes)

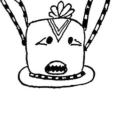

Case mask painted blue or yellow, pop eyes, a broken line of two colors across face under eyes; rectangular mouth, eagle tail feathers in place of ears. Kilt, sash, and blue moccasins. Red body paint, yellow shoulders, forearms, and lower legs.

261. Fox Kachina

Case mask painted yellow, brown or red, with big triangle in black outlined in red or brown on forehead. Snout showing teeth. Large yellow or brown ears bordered by black band with white spots. Kilt, sash, blue moccasins. Body paint, yellow with black forearms, black chest.

262. Sio Kachina Zuñi Kachina

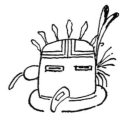

Case mask painted blue-green, eyes rectangular, mouth a yellow beak. One ear a gourd, the other a tuft of hair. Kilt, sash, and blue moccasins. Body paint red, one shoulder yellow, one blue; one forearm and lower leg blue, one yellow. Appears in regular kachina dance. In dance the kachina holds a rattle in right hand and tray in left hand. He represents the spirit of the Zuñi people, not a Zuñi kachina. He resembles both the Navajo Kachina, No. 137, and the Hornet Kachina, No. 68, with which he might be confused.

Fewkes, 1903, Pl. XLV.

263. Mahu Cicada Kachina

Case mask painted orange, rectangular eyes, and a beak. A stripe made up of black and white squares outlined on each side with red reaches from the top of the mask down the face to the beak, which it follows to tip, and similar lines may be horizontal over eyes and on cheek. On top of the head are two soft horns, striped in black, one orange and one blue.

264. Hano Mana

Face mask painted blue-green. Feathers in place of ears. Costume: woman's dress. Specimen in Denver Art Museum, No. QH-54-G.

265. I'she Mustard Green Kachina

Case mask green, red ears, black warrior marks on cheeks, rectangular eyes, triangular mouth. Regular kachina costume. Body paint red with yellow and blue shoulders.

266. Danik'china Cloud Kachina Guard

Basket mask painted green, upper part of head separated by a band of parallelograms of different colors. Face divided in half, one side black, one side yellow, chin of all colors. Kilt, sash, woman's belt. Body painted red with regular kachina painting. Carries branches of Douglas fir. At the Salako dance, four appear, two dance back of the Cloud Kachinas, and two back of Manas. Their function is said to be to act as guards. They make very graceful motions. Appeared at Salako dance at Shungopovi 1935, 1952, and 1957. Said to be the uncles of the Cloud Kachinas.

5. Hopi Deities

THE RELIGION of the Hopi Indians in certain ways resembles that of the ancient Greeks. It is polytheistic, because there are many gods, and animistic because of the belief that all animate objects, plant and animal as well as some inanimate things, have spirits that the Hopi visualize in human form. When a Hopi goes out to gather yucca roots to use as a shampoo, the first plant he finds, he prays to and passes by, gathering the second one. When he goes hunting he prays to the spirit of the game and apologizes for having to take their lives.

In the mind of the Hopi there is a distinction not very sharp between the deities and the spirits of objects. The spirits of men, animals, and plants are the kachinas which are often impersonated. The spirits of some of the deities appear as kachinas and are impersonated, but most of the deities are never impersonated or even represented by images. The Hopi recognize about thirty-six deities. These grade from four major gods through minor gods to folk heroes. It is hard to find a clear separation. Here we will list most of the spirits certain Hopis consider to be deities, not kachinas.

SOTUQNANG-U, God of the Sky (D1)

Sotuqnang-u, the god of the sky, the clouds, and the rain, is good, dignified, and powerful. He is occasionally impersonated in one of two forms, masked and unmasked.

When masked the impersonator wears a white case mask with one horn or a high, peaked headdress or hat. There are cloud designs on the cheeks and at the bottom of the back of the mask.

When unmasked the impersonator wears a hat shaped like a star with feathers hanging over the face, and his hair hanging down his back. His face is painted bluish gray with the sediment from the bottom of a water hole. The chin is painted black. The impersonator wears a white embroidered kilt and wedding sash. His body is of the same bluish gray color that is used on his face. He wears Douglas fir boughs on each shoulder and across his body. If masked he wears moccasins, if unmasked he is barefooted. In his hand Sotuqnang-u carries a lightning frame and bull-roarer (Hough, 1918, fig. 45). It is said that he was once supported by a cult or fraternity which has now been dissolved. Some Hopis who are familiar with the Christian religion identify him with the Christian God.

MASAO, the Earth God (D2)

Masao is the god of the earth, both of the surface and the underground. In his capacity as ruler of the surface of the earth, in ancient days, he allotted the Hopi their lands; as ruler of the underworld he is the god of death.

He is visualized by the Hopi as an ugly young man, very terrifying. He is supposed to mingle with the people and does not hold himself aloof like Sotuqnang-u. He takes many forms and is sometimes impersonated in the fall, spring, and summer ceremonies.

The impersonator wears no mask, and his face is painted

with blood. His body paint is ashes, his belt a yucca string, his kilt a woman's old dress. He is barefooted but wears yucca strings about both legs. In his hands he carries an old coiled plaque and an old digging stick.

KWANITAQA, The One-Horned God (D3)

Kwanitaqa guards the gate to the Hopi underworld, where the departed spirits go, and directs the souls on two paths, one for righteous people and one for evil people. He can do this because he knows people's thoughts. He is a kind god and helped the Hopis come from the underworld.

The impersonator wears a headdress with a single horn turned back. There is a white line under his right eye and another white line around the edge of his chin. His only body paint is a white line on the front of his arms and legs. He wears a wildcat skin or a white wedding robe. He is barefooted and carries a bell and wand.

AŁOSAKA or MUY-INGWA, The Germ God or
Two-Horned God (D4)

Alosaka, the god of reproduction, of man, animals, and plants, plays a very important part in Hopi religion. He is thought of as gentle and kind and holds himself aloof. His home is in the underworld.

He is impersonated at the time of the Wuwuchim in November. The headdress of the impersonator carries two horns that curve back. His hair hangs down his back. The only body paint of Alosaka is a white line down the front of his arms and legs. For a costume he wears a white tanned buckskin. He wears moccasins and has turtle shell rattles tied on his legs. In his hands he carries deer horns and a wand.

HURU-ING WU-UTI, Goddess of Hard Substances (D5)

Huru-ing Wu-uti is the goddess of turquoise, of shell ornaments and in general, of wealth. She is thought of as an ugly

old woman in the daytime and a beautiful young girl at night. Her home is a kiva in the Pacific Ocean. She is believed to be gentle and kind and never mingles with the people.

She is said never to be impersonated and does not take part in any ceremony.

TAWA, Sun God (D6)

The sun god travels the sky every day, ending his trip in the kiva of the Woman of the Hard Substances in the Pacific Ocean. He is considered to be a young, handsome god, gentle, kind, and helpful. He never mingles with the people. He is impersonated at the time of the Soyal Ceremony at Oraibi by a Sun Clan man.

His headdress is white soft eagle feathers and bronze parrot feathers. His face is painted with white corn meal, his body red and blue. He wears an embroidered kilt, ceremonial sash, woman's belt, red fox skin. He is decorated with eagle tail feathers, shell beads, and turquoise, and carries a sun shield and wand.

MU-YAO, Moon God (D7)

The moon god lives in the sky and is thought of as a happy old man. He has the power to give light at night. He never mingles with the people, and is never impersonated. At present, he has no cult, or clan, although in the past there may have been such groups.

TAI-OWA (D8)

Tai-owa is a minor god of ornaments and wealth. He is thought of as a handsome little fellow. He is kind and gentle, and the people love him. He is never impersonated, but the Hopi have an idol, like a big doll, painted yellow, blue, and red, and adorned with shell beads and turquoise, and which some fraternities display on the altar in certain ceremonies.

KOKYANG WU-UTI, Spider Woman (D9)

The Hopi conception of the Spider Woman is hard to understand. She is one person and also many persons, and thus is everywhere. The Hopi respect and love her, for she is gentle and kind and will help people in trouble, and can take revenge on evil gods. She is thought of as a vigorous old woman and is never impersonated, but the Hopi are said to have shrines to her at every village.

Pö-ökang-hoya, and Palö-ngao-hoya, the
 Two Little War Gods (D10, D11)

Twin gods, grandsons of the Spider Woman, mingle with the people and play tricks on them, but if the people are in trouble, they appeal to their wise grandmother who shows them how to outwit evil.

They are sometimes impersonated and the people who take part in the ceremonies keep images of them in their houses. They are not associated with any particular ceremony, but may appear in several, nor are they impersonated by members of any particular society or clan, but by anyone who is selected.

Both war gods are depicted as young boys, but yet as warriors. Pö-ökang-hoya wears a skull cap with feathers. His face is painted black with two vertical white lines, warrior symbols, on his cheeks, and with white around the mouth and eyes; body paint, Supai red with two white spots on each arm, two on the chest and two on each leg. He wears a black breech clout. He usually carries a quiver of arrows, a bow and a lightning device.

Palö-ngao-hoya has a bunch of feathers for a headdress. His face is painted reddish brown with two black vertical lines, warrior symbols, on each cheek. His body is painted reddish brown, and he wears an old style black breech clout. About each leg he wears a hank of yarn, and anklets. He carries a bow, arrows, and a bull-roarer.

Kochoilaftiyo, Poker Boy (D12)

The Poker Boy is visualized as a young boy, the grandson of the Spider Woman, who never mingles with the people or plays tricks on them. He is good and helps people in trouble. No one knows where he lives. He is said never to be impersonated nor are idols made of him, nor does he play a part in the ceremonies.

Pi-tsingsivos-tiyo, Cotton Seed Boy (D13)

He is thought of as a homely young boy living with his grandmother, the Spider Woman. He provides the people with cotton. He is said not to be impersonated nor are idols made to represent him, nor does he play any part in any ceremony.

Pivitamni, Patches (D14)

Patches is thought of as a humble boy who once mingled with the people but now holds himself aloof. He lives with his grandmother, the Spider Woman. His clothes made of mouse skins are the reason for his name. He is a good deity and helpful to the people. He is not impersonated, nor does he play a part in any ceremony.

Öng Wu-uti, Salt Woman (D15)

The Salt Woman is thought of by the Hopi as an elderly woman living at the Salt Lake, 40 miles south of Zuñi. She has the power to predict the seasons. She is a good goddess and provides the people with salt. The Salt Woman is never impersonated and plays no part in any ceremony.

Tikuoi Wu-uti, The Outcast Woman (D16)

The Outcast Woman is thought of by the Hopi as a young woman wearing a white wedding robe. She is a creature of darkness and appears in dreams. She is terrifying and preys

on men. She is like a ghost and scares people. She is not im-
personated and does not play a part in any ceremony.

TALAOTUMSI, Goddess of Reproduction (D17)

Talaotumsi is thought of as a young but ugly woman. She
is represented by a small carved wooden idol which has its
place in the kiva during the Wuwuchim Ceremony, where it
represents the female sex.

TIPONI (D18)

Tiponi is a symbol of what the Hopi call the "mother of
all." Every village has one, as do the principal priests
and chiefs of all fraternities. These tiponi are made by the
One-Horned Societies of all Hopi towns. The object itself
is made of an ear of white corn, which has to be a perfect one,
fastened to a flat wooden base about two inches wide. Soft
eagle feathers and parrot feathers are put over this ear of corn.
Then it is wrapped up in ever so many layers of homespun
cotton yarn exposing part of the feathers at the top. In all
ceremonies these images will have their places in front of the
altar in each kiva, especially in Wuwuchim time in November
and for the Soyal Ceremony in December. At those times,
every man who has one will bring it into his kiva so that it
may receive some pahos, or prayer plumes.

PATUSUNG-ALA (D19, 20, 21, 22)

These are the four gods of the cardinal points and are im-
personated in the Soyal Ceremony in initiation years. Their
headdresses carry five horns and squash blossom ears. The
face paint differs with the points of the compass, yellow for
the god of the north, blue for the god of the west, red for the
god of the south, and white for the god of the east. The body
paint is bluish gray sediment from the bottom of the springs.
These gods are believed to live in the north. They do not

mingle with people, are rather feared, are powerful, but not oppressive.

TAWAVÖKANG, A Servant of the Sun (D23)

This god is impersonated in the Soyal Ceremony in initiation years. His headdress is soft white eagle feathers with parrot feathers. His hair hangs down in the back and his face is painted with white corn meal. His body paint is red, yellow, and blue. He carries a sun shield and a wand. He is said to live in the sky. He is powerful but kind and gentle and is loved by the people.

YAPONCHA, Wind God and Dust Devil (D24)

He is thought of as a horrid-looking creature with shaggy hair, body painted with ashes, and wearing a breech clout. He is never impersonated and takes no part in any ceremony. He is troublesome and is not liked.

KWI-NYAO, God of the North Wind (D25)

Kwi-nyao is thought of by the Hopi as an icy old man with nothing on but a breech clout. At times he associates himself with Yaponcha and causes a lot of trouble. He is associated with no ceremony and is never impersonated.

CHAMAHIYE, Snake Chief of the Underworld (D26)

Chamahiye is the spiritual chief of the snake people. Members of the snake fraternity are said to make a prayer offering for this god at Soyal time in December.

AWAHIYE, Assistant Chief of the Underworld Snake Fraternity (D27)

Although Awahiye is never impersonated, he is visualized as dressed and painted like a snake dancer.

KATOYA (D28)

Katoya is a reptile, looking like a big, short snake. He guards the snake kiva in the underworld. He is not impersonated.

PONOCHONA, The South Star (D29)

Ponochona is the god of the domestic animals, controlling reproduction. He lives far down in the southern skies. He is never impersonated and plays no part in ceremonies.

HACHOKATA, God of the Gamblers (D30)

Although he is never impersonated, the God of the Gamblers is thought of as a shaggy haired old man in a breech clout who lives in the underworld. He is powerful and oppressive and once mingled with people and played tricks on them. Gamblers make prayer offerings to him.

CHIMON MANA, Jimson Weed Maiden (D31)

Everyone is afraid of this deity as she preys on males. Although never impersonated, she is thought of as a young maiden, rather good looking but not beautiful. She is a trouble-maker and has the power to make people insane.

PASOM MANA, Spiderwort Maiden (D32)

Pasom Mana is a bad deity with no place in ceremonies, and is never impersonated. She lives in a pasomi (spiderwort) plant in Jeddito Valley. She visits people in their dreams and makes them insane.

SOMAIKOLI (D33)

This deity is sometimes impersonated like a kachina, but is not considered to be one. He takes part in the Yaya Ceremony in the fall, and is impersonated by one of the fraternity members. He is considered to be young, handsome, kind and helpful with powerful magic. He is supposed to live at a special place on the edge of the mesa.

KAWIKOLI, Fire Chief (D34)

He is impersonated like a kachina, but is not considered to be one. He takes part in the Yaya Ceremony in the fall. He is kind and helpful and lives with Somaikoli on the edge of the mesa.

SIWIKOLI (D35)

He is sometimes impersonated like a kachina but is not considered to be one. He takes part in the Yaya Ceremony in the fall, and lives with Somaikoli on the edge of the mesa. Like others of the Koli group he is kind and helpful with magic, but unlike the others, he is ugly.

PALÖLÖKON, Plumed Serpent or Water Serpent (D36)

A great snake, supposed to frequent certain springs, is the central figure of the Water Serpent Ceremony, a drama with several acts, held sometimes in certain kivas in the spring after the Bean Dance. The snake is manufactured of a series of hoops covered with cloth and is manipulated by a man behind a screen.

6. How to Identify Kachina Dolls

Use of the Key

> ". It now will be right
> To describe each particular batch,
> Distinguishing those that have feathers, and bite,
> From those that have whiskers, and scratch."*

IN A PREVIOUS chapter some 266 different kachinas have been recognized, and each described by about ten characteristics. With so many characters to be kept in mind, the identification of individual dolls is very laborious without some kind of a mechanical aid. By dividing the kachina dolls into many small classes, the members of which have some characters in common, the problem is greatly simplified. To accomplish this a key to the dolls has been prepared, the kind of key selected being one that experience has shown is easy to work and economical of space.

The key, which follows, consists of forty-three tables, in each of which are listed two or more categories based on details of mask and costume, and illustrated by a simplified drawing of the mask. Each category is either followed by a

* From *The Hunting of the Snark* by Lewis Carroll. 1st. Ed. 1876, London.

reference to a subsequent table, or the name of a specific kachina doll with its serial number.

For those of our readers who are unfamiliar with the use of keys, we supply an example of how to identify a kachina doll. Suppose that you have purchased a kachina doll from a curio store, and you are curious to know the name of the kachina it represents. You should first look over your doll very carefully. Suppose you note that it has a black case mask with diamond shaped eyes, a horizontal mouth with a beard, and wears a male costume. With this information at hand you attack the key.

Starting with Table 1, you will note that thirteen contrasting characters are listed. You will find that the last category satisfies the conditions of your doll; that is, a case mask carrying no features such as tableta, tripods, or horns. This thirteenth category refers you to Table 8. Turning to Table 8, you will find twelve categories that have to do with the mouth, and you will note that the eighth category satisfies the description of your doll, namely a case mask with a horizontal mouth and a beard. You are now referred to Table 26. In this table, which has to do with the kind of eyes, note that of the two kachinas with diamond-shaped eyes, one wears a male costume and the other a female costume. Since your doll has a male costume (see Chapter 3), it must be a Left-handed Kachina, No. 95. The description can be confirmed by turning back to Chapter 4 and looking up the kachina numbered 95.

Try the key on another kachina doll, always beginning with Table 1, and following through each step; if you have a genuine Hopi kachina doll you can probably identify it quickly. A few of the kachinas mentioned in Chapter 4 have not been included in the key. Although they were figured by Dr. Fewkes fifty years ago, with very little data, they are now unknown to any of the Hopis that we have consulted. Therefore, they are not likely to be represented by dolls. The

kachinas not given in the key are distinguished by an as-
terisk preceding the number, in the list of descriptions in
Chapter 4.

There are several reasons why your doll might not key out.
It might be a doll made by a Hopi for the tourist trade that
combines the characters of several kachinas, a genuine
kachina doll made by another Pueblo Indian tribe not Hopi,
a doll made by a white manufacturer of spurious Indian
goods, or just a Hopi doll. Some common Hopi dolls (we
do not call them kachina dolls) represent unmasked figures
that take part in certain ceremonies, for instance:

1. Snake Dancer, which has lower half of face painted black. Wears a
 brown kilt painted with white zigzags. A snake carved from wood is
 usually carried in the mouth.
2. Butterfly Maiden wears an ornate tableta, usually decorated with
 butterfly symbols. She has red spots on the cheeks, and wears a woman's
 black dress.
3. Buffalo Maiden has a white face, and wears no tableta. Wears a
 woman's white costume.
4. Buffalo Man has a black face, a woolly black wig with buffalo horns
 at the side. Kilt and body paint like a Snake Dancer's.
5. Lakon Mana, a basket dancer, has a yellow face, with horizontal black
 bands, and often the headdress consists of a single horn on one side of
 the head balanced by a fan-like decoration on the other. Similar to
 Kachina No. 164, Ahaolani.
6. Flute Maiden has a white face. The headdress consists of flowers carved
 of wood similar to those worn by the Flute Kachina, No. 106.

The individual craftsmen who make kachina dolls vary
greatly in their knowledge and ability, so that several dolls
representing one kachina may look quite different from each
other, yet the characters that distinguish one kachina from
another are so constant that they are never omitted. As we
have had to depend, in some cases, on a single doll for the
diagnostic characters from which to make the key, through
ignorance we may have selected a variable character that
might be omitted on another doll.

In preparing the key, we have tried to keep in mind these above-mentioned variations, as well as other difficulties. Because a man who carves a doll does not always distinguish between a case mask and a sack mask, we have tried to avoid the use of mask types as a distinctive criterion. When a mask type is used as a criterion, and the doll does not key out, it is well to try the alternate mask character. Too much stress should not be placed on the symbols that are painted on the cheeks of some kachina masks, as they are sometimes omitted from the dolls.

It is difficult to find any constant character that will distinguish Hopi from Zuñi kachina dolls, for the Hopi make a good many dolls representing Hopi versions of Zuñi kachinas, so that the same kachina may be manufactured by both tribes. It is a general rule that the Zuñi dolls are taller and thinner; sometimes they have arms that are carved from separate pieces of wood and are movable. The costume of the Zuñi doll is sometimes made out of fabric and not carved. Dolls with the above characteristics that will not key out may be suspected as being of Zuñi origin. With these cautions and suggestions in mind, you should now be prepared to use the key.

Key to the Identification of Hopi Kachina Dolls

TABLE 1

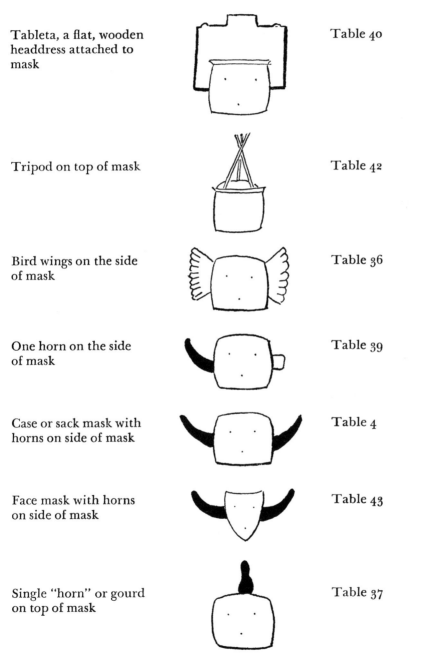

Tableta, a flat, wooden headdress attached to mask — Table 40

Tripod on top of mask — Table 42

Bird wings on the side of mask — Table 36

One horn on the side of mask — Table 39

Case or sack mask with horns on side of mask — Table 4

Face mask with horns on side of mask — Table 43

Single "horn" or gourd on top of mask — Table 37

TABLE 1

Animal horns, such as
deer, antelope, etc., on
top of the mask

Table 3

A pair of pseudo-horns
on top of mask

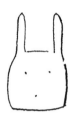

Table 2

Three horns on top of
mask
White case mask with
snout

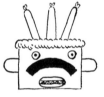

Three-horned
Kachina 168

Four horns on top of
mask
Case mask ½ green,
½ yellow
Beard

Four-horned
Kachina 218

Half mask

Table 24

Case, sack or face mask.
No tableta, tripod or
horns. The top or the
sides of the head mask
may have red ears or
flowers in place of ears

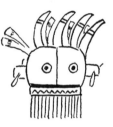

Table 8

TABLE 2 SOFT HORN-LIKE STRUCTURES (PSEUDO-HORNS) ON TOP OF HEAD

Sack mask painted yellow. Warrior marks on cheeks	Scorpion Kachina	52
Sack mask, horns with black and white stripes	Hano Clown	60
Yellow mask, black half-circles across eyes, pointed bill	Bee Kachina	67
Sack mask, painted with horizontal stripes of many colors, with long bill	Hornet Kachina	68
Muddy yellow case mask	Cricket Kachina	64

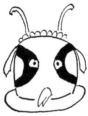

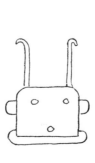

TABLE 3

Case mask, face green or 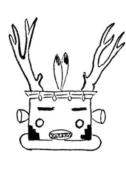 Antelope Kachina 90
sometimes white.
Antelope horns on top
of mask, blossoms in
place of ears. Snout

Deer horns on top of Deer Kachina 91
mask, blossoms in the
place of ears. Snout

Black case mask, Mountain Sheep
mountain sheep horns Kachina 92
on top of mask,
horns turn back.
Snout

Black face mask. Bison Buffalo Kachina
horns on top of mask. (Second Mesa) 93
Snout

Green or white case Cow or Steer
mask. Cow horns on Kachina 94
top of mask.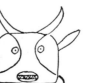
Snout

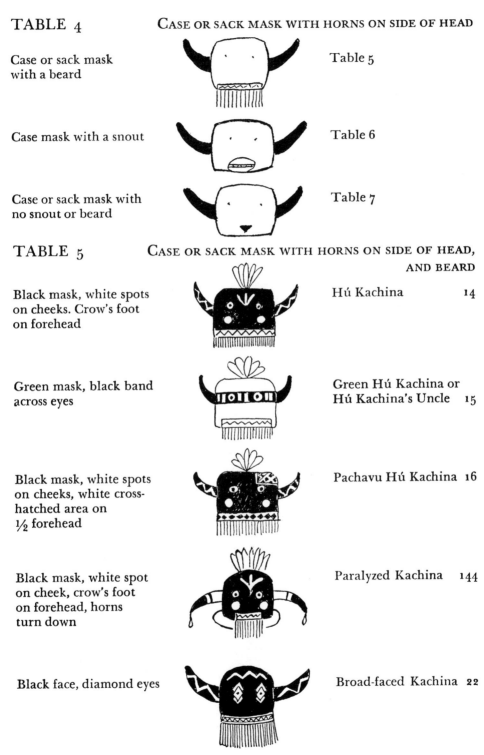

TABLE 4 CASE OR SACK MASK WITH HORNS ON SIDE OF HEAD

Case or sack mask
with a beard Table 5

Case mask with a snout Table 6

Case or sack mask with
no snout or beard Table 7

TABLE 5 CASE OR SACK MASK WITH HORNS ON SIDE OF HEAD,
AND BEARD

Black mask, white spots
on cheeks. Crow's foot
on forehead Hú Kachina 14

Green mask, black band
across eyes Green Hú Kachina or
Hú Kachina's Uncle 15

Black mask, white spots
on cheeks, white cross-
hatched area on
½ forehead Pachavu Hú Kachina 16

Black mask, white spot
on cheek, crow's foot
on forehead, horns
turn down Paralyzed Kachina 144

Black face, diamond eyes Broad-faced Kachina 22

TABLE 6 MASKS WITH HORNS ON SIDE OF HEAD, AND SNOUT

Black mask, crow's foot
on forehead, (a) very big
snout (b) medium sized
snout

(a) Black Ogre
(Nataska) 29
(b) Atosle 28

Black mask, lazy V back
of eyes. Very big snout

Black Ogre's Uncle 30

White mask, crow's foot
on forehead, very
big snout

White Ogre 31

Black mask, moon on
one cheek, star on the
other. Medium snout

Ho-ó-te 104

Brown mask, bear track
under eyes. Medium
snout

Hototo 186

Green or black mask,
bison horns. Medium
snout

Buffalo Kachina
(First Mesa)
93

Black case mask, mouth
slightly raised

Big Head Kachina 102

Green mask, black band
across eyes, medium
snout.
Man's red moccasins
Woman's white boots

Zuñi Salako 158
Zuñi Salako Mana 159

TABLE 7 Masks with horns on side of the head, no snout or beard

White case mask, triangular mouth, stepped rectangles of many colors over mouth

Supai Kachina 143

White case or face mask, triangular mouth, many colored radiating segments on chin

Supai Kachina 143

TABLE 8 Case, sack, or face masks without tabletas, wings, horns, tripods, etc. May have red ears or flower ears

Case or sack mask with a tube mouth

Table 9

Face mask with a tube mouth

Table 10

Case or sack mask, snout, red ears

Table 19

Case or sack mask, snout, no red ears

Table 20

TABLE 8

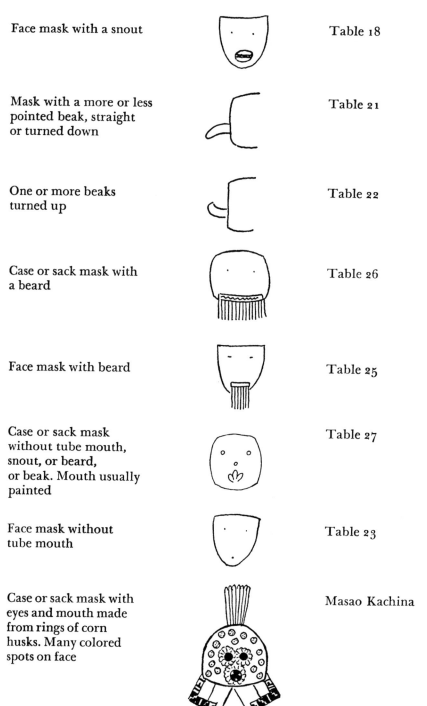

Face mask with a snout Table 18

Mask with a more or less
pointed beak, straight
or turned down Table 21

One or more beaks
turned up Table 22

Case or sack mask with
a beard Table 26

Face mask with beard Table 25

Case or sack mask
without tube mouth,
snout, or beard,
or beak. Mouth usually
painted Table 27

Face mask without
tube mouth Table 23

Case or sack mask with
eyes and mouth made
from rings of corn
husks. Many colored
spots on face Masao Kachina 123

TABLE 9 CASE OR SACK MASKS WITH TUBE MOUTH

Round eyes Table 11

Rectangular eyes Table 12

Pothook eyes Table 16

Eyes joined together Table 17

Brown case mask, 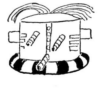 Mocking Kachina 107
telescope eyes, white
horizontal lines
on cheeks

Case mask, one eye a 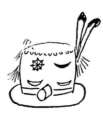 Hishab Kachina 193
flower or sun, and the
other the moon

TABLE 10

White or green face
mask, on one cheek
horizontal zigzags
and on the other
horizontal bands
of color

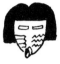

Field Kachina 197

White face mask with
red bands across eyes,
zigzags on cheeks.
Skull cap

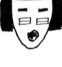

Apache Kachina 205

Green face mask, yellow
and red rectangles on
cheeks

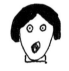

Old type of Navajo
Kachina Maiden 136

Orange face mask, red
spots on cheeks. Navajo
woman's costume

Navajo Kachina
Maiden 138

Maroon face mask, male
costume

Samawutaqa 176

White face mask with
vertical zigzag lines,
maiden's whorls

Heheya Kachina
Maiden 35

White face mask,
inverted V
over mouth

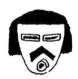

Kuwantotim 244

TABLE 11 CASE MASKS WITH TUBE MOUTH AND ROUND EYES

White mask, white hair in maiden's whorls, woman's dress	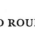	Snow Kachina Maiden	100
Mud colored mask, diagonal hachures in red under the eyes, feather beard, female costume	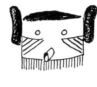	Masao Kachina Maiden	124
Black mask covered with spots of all colors	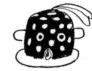	Zuñi Fire God Kachina	151
Black mask, two lightning zigzags in place of nose, red tube mouth		Zuñi Corn Kachina	166
Black mask, covered with white circles. Four feathers form a cross on top of head	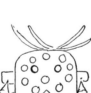	Hopi Spotted Corn Kachina (old type)	122
Yellow mask, white and red stripes in place of nose		Chipmunk Kachina	56
White or green mask	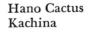	Hano Cactus Kachina	204

TABLE 12

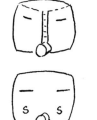

Vertical line in place
of nose

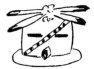

Symbols of some sort
on cheeks

Case mask, pink or
green, black border.
Inverted V over mouth.
Four flowers on head

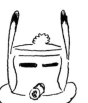

Green mask, with red,
black, and yellow
inverted V over mouth

Diagonal stripe divides
face into red and yellow
portions

Green mask, framed in
purple. Top of mask
red

Green mask, white
stepped area about eyes

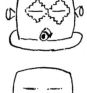

No special face features

CASE MASKS WITH TUBE MOUTH
AND RECTANGULAR EYES
Table 13

Table 14

Velvet Shirt Kachina 171

Kau-a Kachina
(old type) 135

Sunset Crater
Kachina 142

Kwasus Alektaqa 214

Snow Kachina 99

Table 15

TABLE 13 CASE MASKS WITH TUBE MOUTH, RECTANGULAR EYES,
NOSE A VERTICAL LINE

Green case mask, or half green, half reddish-brown. Sometimes reddish or green half-ovals under eyes

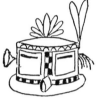

Qoia Kachina 135

Case mask, half red, half green, nose line a checkerboard. Blossom in place of one ear, tuft of hair on other

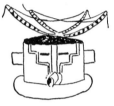

Malo Kachina 130

Case mask of different colors. Eyes surrounded by terraced white areas. Body paint pink with white circles or vice versa

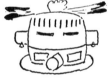

Zuñi Spotted Corn Kachina 122

TABLE 14 CASE MASKS WITH TUBE MOUTH, RECTANGULAR EYES,
SYMBOLS ON CHEEKS

Green case mask, rectangles of color on each side of mouth

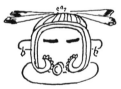

"Peeping Out Man" 235

Green case mask. Bean sprout symbols under eyes on each side of mouth

Muzribi 188

Green case mask, flowers painted on forehead and under eyes

Prickly Pear Kachina 109

Brown mask, blue area about eyes. An hour glass in white under eyes

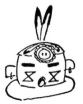

Big Forehead Kachina 201

TABLE 14 CONTINUED

Green mask, cross-hatched stepped elements under eyes	Rügan A	238
White face mask, blue and red border, corn symbols under eyes	Rügan B	239
Green face, stepped elements under eyes not cross hatched	Rügan C	240
Green or brown face, acute triangles under eyes. White shirt, black kilt	Piokot	174

TABLE 15 CASE MASKS WITH TUBE MOUTH, RECTANGULAR EYES, NO CHEEK FEATURES

Green mask. Eagle feather in place of ears, red tube mouth. Hank of blue yarn across forehead	Mad Kachina	145
Green mask; in place of hair on head, parallel lines of all colors	Turtle Kachina	70
Black mask, red and green stripes on forehead. Beak or tube mouth.	Hömsona	51

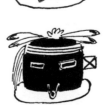

TABLE 16　　　CASE MASKS WITH TUBE MOUTH, POTHOOK EYES

Black mask, green and yellow stripes across forehead

Hömsona　　51

Blue-green mask, blossom ears. Usually has a beak

Navajo Kachina　　137

Brown mask with a green center area. May have an abalone shell on forehead

War Leader Kachina　　140

Green case mask, cloud symbols on cheeks

Early Morning Kachina　　108

TABLE 17　　　CASE MASKS WITH TUBE MOUTH, EYES JOINED TOGETHER

Green mask, no ears. Hair on top of mask

Zuñi Sun God Kachina　　150

Mask of any of the six colors. Painted flowers in place of ears

Zuñi Warrior God Kachina　　152

TABLE 18　　　FACE MASKS WITH SNOUT, NO HORNS OR TABLETAS

Green face mask, inverted V over medium snout

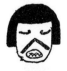

Mountain Lion Kachina　　85

Black mask, medium snout, warrior marks on cheeks

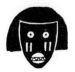

Mad Kachina (Third Mesa)　　198

TABLE 19 Case or sack masks with snout and red ears

Black mask, crow's foot on forehead, black kilt	Sand Kachina	167
Brown mask, green eyes, yellow band across eyes	Squirrel Kachina (Second Mesa)	83
Pink mask, white diamond enclosed eyes. Diamond on cheeks	Cocklebur Kachina	149
Green or black mask with a yellow area around mouth. With or without lizard carried in snout	Lizard Kachina	69
Green mask, cactus on head and cactus flowers painted on cheeks	Cholla Cactus Kachina	43
Mask may be any color, or ½ yellow, ½ green, red eyes, bear tracks painted on cheeks, sometimes a green band below eyes	Bear Kachina	87
White case mask with snout. Horses painted on cheeks	Horse Kachina	181
Black mask with white center area, yellow-green eyes. Badger paw painted on cheeks	Badger Kachina	89

TABLE 19

White or black sack mask. Cat tracks painted on cheeks		Wildcat Kachina	84
Brown mask, half moons under eyes, green, red, and white		Hólolo (Second Mesa)	103
Green mask, rectangles with dots on each side of mask under eyes and continuing on the ears		Hólolo (Third Mesa)	103
Green mask, black band across eyes		Hochani	113
Yellow or black mask, black and red stars		Hóte	105
Green mask, warrior marks on cheeks in black		Qaletaqa	4
White mask, built out mouth not a true snout. Feathers through the ears		Tanakwewa	42

TABLE 19

Black mask, extra large snout, crow foot or dots on forehead

Chaveyo (First Mesa) 37

Chaveyo (Third Mesa) 37

Green case mask with a snout, Devilsclaw seed pods painted on cheeks, row of real seed pods above visor

Devilsclaw Kachina 243

Green case mask, black band with white squares across eyes, band outlined with red. Mouth square with painted teeth

Sikya-chantaka 253

Brown case mask, pop eyes. Blue warrior marks on cheeks

Yo-we 255

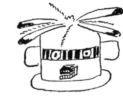

Sack mask basically green with red, black, and green horizontal lines under the eyes; diagonal lines of same color on each side of mouth

Angry Kachina 256

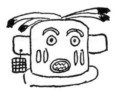

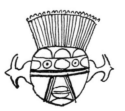

TABLE 19 Continued

Case mask painted green or blue. Band of alternating white squares across eyes. Rectangular mouth		Crazy Rattle Kachina	258
Brown case mask with juniper bark hair. Tubular eyes and mouth painted with stripes. Three white lines under eyes. May have snout		Mocking Kachina	107

TABLE 20 Case or sack masks with snout, without red ears

Case mask painted blue or yellow. A broken line of two colors across face under eyes; rectangular mouth		Holi	260
Round eyes, brown mask with or without wolf tracks on cheeks. Pointed ears		Wolf Kachina	86
Brown face mask, round eyes, painted snake carried in mouth	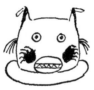	Saviki	121
Black mask, or one side green and one side pink with center area white, yellow-green eyes	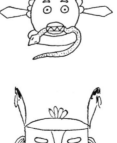	Badger Kachina	89

TABLE 20 Continued

Brown mask, diamond shaped eyes, warrior marks on cheeks		Squirrel Kachina 83
Yellow mask, rectangular eyes, flower as one or both ears	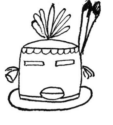	Big Head Kachina (Third Mesa) 102
White or pink mask with stepped elements under rectangular eyes. Kilt of bright colored material		A Proud Kachina 169
White mask, inverted V over snout. Pink body paint, red hair in place of ears		Proud War God Kachina 180
Black case mask, warrior marks on cheeks, woman's costume, carries crook		Awatovi Soyok Wuuti 25
White case mask; wears rabbit skin blanket		Awatovi Soyok Taqa 26

TABLE 20 CONTINUED

Yellow mask, white and red stripes in place of nose

Chipmunk Kachina 56

May be either carved head or sack mask. Snout usually yellow. Most characteristic symbol is five or more dots on each cheek

Dog Kachina 257

Case mask, painted yellow, brown, or red, with large triangle in black outlined in red or brown on forehead. Snout showing teeth. Large yellow or brown ears bounded by black band with white spots

Fox Kachina 261

White case mask, rectangular eyes. Hourglass symbol on cheeks

Nihiyo 245

TABLE 21 MASKS WITH MORE OR LESS POINTED BEAKS, STRAIGHT OR TURNED DOWN

Yellow mask, black curved band across eyes, antenna on head

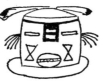

Bee Kachina 67

Wings on side of head, feathers over face

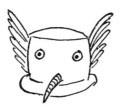

Great Horned Owl Kachina (First Mesa) 78

TABLE 21

Feathers over face,
rabbit tail ears.
 a. Woman's costume
 b. Rabbit skin blanket
 c. Man's Kachina
 costume

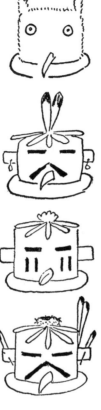

a. Owl Woman 79
b. Screech Owl
 Kachina 80
c. Timber Owl
 Kachina 81

Green mask, inverted V
over beak

Eagle Kachina 71

White mask, warrior
stripes on cheek

Prairie Falcon
Kachina 72

Pink mask, rectangular
eyes, inverted V over
beak. Sometimes a
nest on top of mask

Red-tailed Hawk
Kachina 73

Green mask, long beak,
rectangular eyes, yellow
on top of mask

Hummingbird
Kachina 76

White mask, inverted V
over beak made of shells
and corn husks

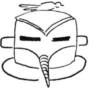

Mockingbird
Kachina 77

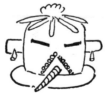

Green case mask,
inverted V over beak.
Headdress in shape
of a bird

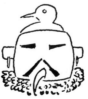

Canyon Wren
Kachina 74

TABLE 21

Green case mask, rainbow-like figure on the side of the head

Snipe Kachina 206

Green mask with red central portion, hook eyes, comb of feathers

Rooster Kachina 82

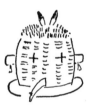

Green case mask covered with rows of small crescents

Road Runner Kachina 207

Wide duck bill

Duck Kachina 75

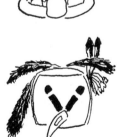

Front of mask purple, top and back red, yellow beak

Tunei-nili 134

Green case mask, hook eyes, blossom ears

Navajo Kachina 137

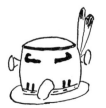

TABLE 21

Mask of many colors;
horizontal stripes, red
ears; or green case mask,
all colors around face,
and datura flower ears

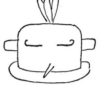

Hornet Kachina 68

White mask, white
wedding robe; or green
mask with woman's dress

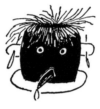

Skirt Man 111

Black case mask with
beak, hair mussed up,
woman's dress; often
carries a cleaver or knife

Soyoko 24

Black case mask with
red, green, yellow stripes
on forehead

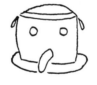

Hömsona 51

Vertical striped mask of
many colors

Flower Kachina 45

Basket mask, tongue
hanging out of beak

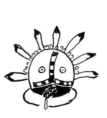

Long-billed Kachina 41

TABLE 21

Black mask, beak made of corn husk, red cotton kilt

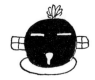

Red Skirt Runner 57

Blue case mask with white face set off with red and black lines. Rectangular eyes. Black beak

Sun Turkey 250

Case mask, painted blue-green. Eyes rectangular, beak yellow. One ear a gourd, the other a tuft of hair

Sio Kachina
Zuñi Kachina 262

Case mask painted orange. Rectangular eyes. Stripe, made up of black and white squares outlined on each side with red, reaches from top of mask down the face to the beak which it follows to tip. Two soft horns on top of head

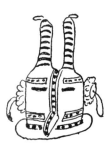

Cicada Kachina 263

TABLE 22 <small>MASKS WITH ONE OR MORE BEAKS TURNED UP</small>

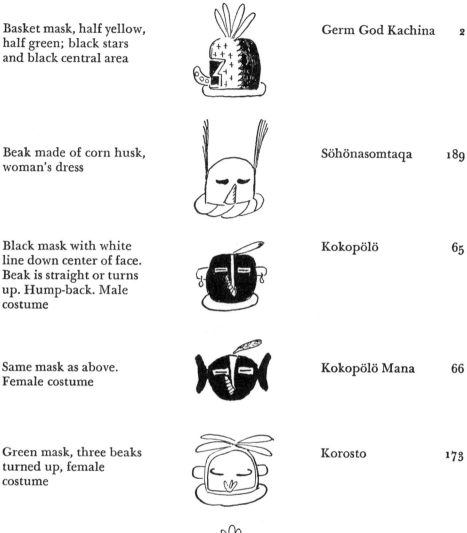

Basket mask, half yellow, half green; black stars and black central area	Germ God Kachina	2
Beak made of corn husk, woman's dress	Söhönasomtaqa	189
Black mask with white line down center of face. Beak is straight or turns up. Hump-back. Male costume	Kokopölö	65
Same mask as above. Female costume	Kokopölö Mana	66
Green mask, three beaks turned up, female costume	Korosto	173
Green or white mask. Single beak or three beaks. May be a face mask	Skirt Man Kachina	111
Green mask. Rectangular or hook eyes. Three beaks. Cloud symbols on cheeks	Talavai Kachina	108

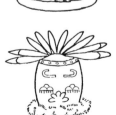

TABLE 23		FACE MASKS WITHOUT TUBE MOUTH

Face mask, male costume — Table 28

Face mask, female costume — Table 38

TABLE 24		HALF MASKS

Green half mask, feather beard. Male costume
 a. Wears moccasins
 b. Barefooted

a. Long-haired Kachina 127
b. Barefoot Kachina 126

White half mask, feather beard, carries white corn. Female costume

White Corn Maiden 128

Yellow half mask, feather beard. Female costume

Pachavu Mana 23

Yellow half mask, feather beard, female costume.
 a. Carries yellow corn
 b. Carries blue corn

a. Yellow Corn Maiden 129
b. Blue Corn Maiden 165

White half mask, black line with white panels over beard, female costume

Alo Mana 215

Yellow half mask with fine red vertical lines, feather beard, red wig

Hemis Kachina Mana 133
Kwavonakwa 178
Ahöla Mana 3
Aha Mana 11

Half mask, painted green with yellow terraced elements on cheeks

Tasaf Anya 251

TABLE 25

Black face mask with round eyes, maiden's whorl on one side of head, hair loose on other; female costume		Hé-é-e Chakwaina Mana Chakwaina Sho-adta	21 163 162
Black face mask, crescent eyes, lamb skin wig, male costume		Chakwaina	160
White face mask, vertical zigzag lines under eyes, male costume		Mad or Stone Eater Kachina	198

TABLE 26

Black case mask, white chin, maiden's whorls, female costume		Soyok Mana	27
Black case mask, mussed up hair, female costume. Carries a crook		Soyoko	24
Mud colored case mask. Woman's costume		Masao Kachina Maiden	124
Case mask, half black with white stars, half white with black stars, separated by a diagonal line		Warrior Kachina	202

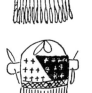

TABLE 26

Case mask, white, stars on the headdress or face		Star Kachina 147
Mask half green, half brown, separated by diagonal line		Hilili 185
Black mask, stepped area about eyes. May have a sun symbol on side of mask		Hilili 185
Green mask, horizontal mouth		Tutumsi 112
White mask, red cheeks, tongue hangs out. Female costume		Horo Mana 101
Pink mask, black band across eyes		Hototo 186
Black mask, diamond shaped eyes, male costume		Left-handed Kachina 95

TABLE 26 CONTINUED

Black mask, diamond
eyes, female costume

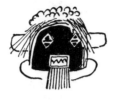

Chakwaina's Mother 161

Case mask, face painted
black, outlined with two
white lines. Rectangular
mouth. Sheepskin wig
with mussed-up long
hair

Dishevelled Kachina 254

TABLE 27 CASE OR SACK MASKS WITHOUT TUBE MOUTH, SNOUT,
BEAK, OR BEARD; AND WITHOUT HORNS,
WINGS, TABLETAS, ETC.

Sack mask

Table 29

Case mask with no
obvious mouth

Table 30

Case mask with
triangular mouth

Table 31

Case mask, triangular
mouth, cross diagonal
hachures on cheek

Table 32

Case mask with round or
oval mouth, red ears

Table 33

Mask with round mouth,
no red ears; may have
flowers or hair in place
of ears

Table 34

TABLE 27 CONTINUED

Mask with rectangular mouth which may extend width of mask. No beard, no horns	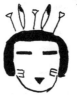	Table 41
Case mask, crescent shaped mouth		Table 35
Case mask, crooked mouth, zigzag lines above and below eyes		Heheya 34

TABLE 28 FACE MASKS WITH MALE COSTUME. NO SNOUT, TUBE MOUTH, BEAK, OR BEARD

Green mask, triangular mouth, horizontal panels on cheeks, long hair		Maswik Kachina 115
Green mask with triangular mouth, diagonal black lines on yellow ground. One eye blue, one yellow		Flute Kachina 106
Green mask, rectangular mouth		Butterfly Kachina 119
Mask divided into three parts, green, yellow, and red; white about the mouth		White Chin Kachina 141
White mask, nose carved out of wood. Red paint on cheeks. Lamb skin wig	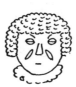	Piptuka 61

TABLE 28 CONTINUED

White mask, red inverted V over mouth, lamb skin wig	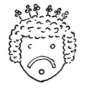	Hó-e	40
Red mask, round mouth, flowers in hair. Rectangles under eyes	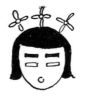	Powamui Kachina	38
White mask, carved nose, inverted V over nose. Lamb skin wig	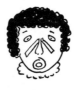	Cross-legged Kachina	125
White mask, carved nose, straight hair	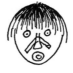	Bluebird Snare Kachina	203
Brown mask, carved nose, cloth headdress	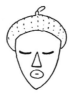	Loi-isa	177
Pink mask, carved nose, built out mouth		Hapota	192
Brown mask, red bands across eyes and mouth	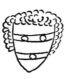	Tsuku	62

TABLE 28 CONTINUED

Reddish brown mask, blue bands bounded by red across eyes and mouth	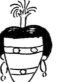	Kaisale	63
White mask, radiating colors on chin		Supai Kachina	143

TABLE 29 SACK MASKS WITH NO SNOUT, TUBE MOUTH, BEAK OR BEARD

White mask with black horizontal stripes, horns of soft material	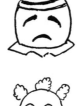	Hano Clown	60
Yellow or mud colored mask		Mud Kachina	53
Yellow mask, Globe Mallow plant on top of mask		Globe Mallow Kachina	54
Mask yellow on one side, blue-green or red on the other		"He Strips You" Kachina	50
Lavender mask with diagonal white line bordered with red		We-u-u	33

TABLE 29

Brown mask, green lines on cheeks and forehead. Mouth raised	Mud Head Ogre	32
Black mask, covered with spots of all colors	Zuñi Fire God Kachina	151
Black mask, raised mouth, red kilt	Red Kilt Runner	57
Black mask: a. red horizontal stripes b. white horizontal stripes	a. Dragon Fly Kachina b. Dung Carrier	58 247
Black mask, white eyes, kilt a woman's old dress	Coal Kachina 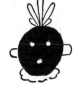	248
Yellow mask, no kilt	Chili Pepper Kachina 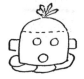	182
Yellow mask, pointed ears, no kilt	Red Fox Kachina 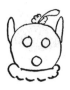	55

TABLE 29

Yellow or black mask, warrior marks on cheeks		Scorpion Kachina	52
Reddish brown mask, gourds on top and side of the head	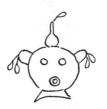	Mud Head Clown	59
White mask, inverted V over mouth, lamb skin wig		Hó-e	40
White mask, red cheeks, crescents under eyes and mouth, woman's costume	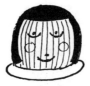	Kachina Mother	44
Black mask covered with spots		Kokosori	9
Black mask, no spots	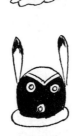	Wik-china	49

TABLE 30

White mask, swastika-
like figures on side
of head

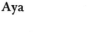

Aya 48

Green mask, Maltese
cross on sides of mask

Rattle Kachina
(Third Mesa) 110

Green mask, painted
flower on sides of mask

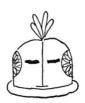

Rattle Kachina
(Second Mesa) 110

Black mask with white
hand, outlined in red,
covering the front
of the mask

Pot Carrier Man 114

Green star on a black
field on front of mask

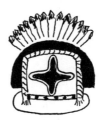

Planet Kachina 148

High conical mask
painted white

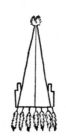

Sotuqnang-u, a deity,
not a kachina D1

TABLE 31 MASKS WITH TRIANGULAR MOUTHS

Cross hachures on cheeks		Table 32	
White mask, warrior marks on cheeks, black hair, woman's costume		Prickly Pear Cactus Maiden	221
White mask, warrior marks, white hair, woman's costume		Snow Kachina Maiden	100
High conical mask of many colors		Aholi	8
Green mask, cloud symbols on cheeks, pothook eyes		Silent Kachina (First Mesa)	46
Green mask, crossed shingles on top of mask		Cross Crown Kachina	200
Circular basket mask, forehead half red and half yellow, rest of face green		Sun Kachina	146

TABLE 31

Green mask, pothook eyes, cloud symbols on cheeks		Flower Kachina	194
Green mask, band across forehead		River Kachina	236
Green mask, warrior marks		Making Thunder Kachina	237
Basket mask painted green; upper part of head separated by a band of parallelograms of different colors. Face divided in half, one side black, other side yellow. Mouth or chin of all colors	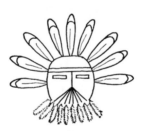	Cloud Guard	266
White sack mask, cloud symbols on forehead		Chowilawu (Third Mesa)	20
Green case mask, red ears, black warrior marks on cheeks. Rectangular eyes	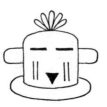	Mustard Green Kachina	265

TABLE 32 MASKS WITH TRIANGULAR MOUTH,
DIAGONAL HACHURES ON CHEEKS

Green mask, diagonal
hachures on cheeks
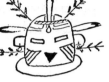
Silent Kachina
(Third Mesa) 46

Green mask, twisted yarn
across forehead, costume
a wildcat skin
A-ha 10
Qalavi 17

Green mask, twisted yarn
across forehead. White
costume
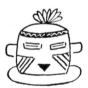
Solstice Kachina 1

Green mask, hanks of
twisted yarn across fore-
head. Regular kachina
costume
Compassionate
Kachina 18

Green face mask, yellow
triangles under eyes
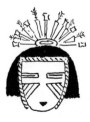
Flute Kachina 106

TABLE 33 SMASKS WITH CIRCULAR OR OVAL MOUTH AND RED EARS

Brown mask		Kwitanonoa	183
Yellow mask, no kilt		Chili Pepper Kachina	182
Muddy yellow mask, antennae on top of mask	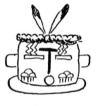	Cricket Kachina	64
White mask, black band across eyes, kilt a woman's old dress, barefooted	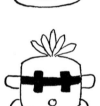	Ashes Kachina Terrific Power Kachina	19 20
Green or yellow mask, nose a painted **T**, zigzag lines above and below the eyes. Sometimes cloud symbols on cheeks, and mouth round or crooked		Heheya	34
Lavender mask, diagonal white line bordered with red	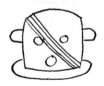	We-u-u (Second Mesa)	33
Green and brown mask, separated by a diagonal white line	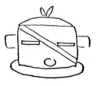	We-u-u (Third Mesa)	33

TABLE 33 CONTINUED

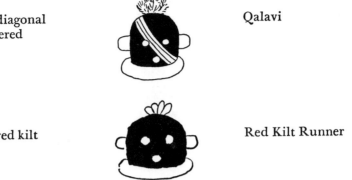

Black mask, diagonal red line bordered by green		Qalavi	17
Black mask, red kilt		Red Kilt Runner	57
Green mask, face framed in lines which end in bean symbols		Muzribi	188

TABLE 34 MASKS WITH CIRCULAR MOUTH WITHOUT RED EARS

Black mask, white crow's feet under eyes		Qöqlö	5
Black sack mask with spots of all colors		Kokosori	9
Black mask with area around mouth white. White spots under eyes		Mastof	6

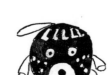

TABLE 34

Black sack mask with white rings about eyes		Greasy Kachina	49
Yellow sack mask		Red Fox Kachina	55
Green mask with black around eyes and mouth. May have lines on cheeks		Hakto	153
Yellow sack mask with warrior marks on cheeks		Scorpion Kachina	52
White mask, no ears, white male costume		Kachina Chief	7
Black mask with red horizontal lines across face		Dragon Fly Kachina	58
Red face mask, flowers in hair	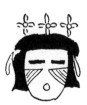	Powamui Kachina	38

TABLE 35

MASKS WITH CRESCENT-SHAPED MOUTH

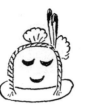

Green case mask, crescent eyes and mouth, white male costume

Solstice Kachina (First Mesa in Flute Dance Year) 164

Black mask, white zigzags in place of nose, woman's dress

Hoho Mana 156

White mask, red spots on cheeks, crescents under eyes and mouth

Kachina Mother 44

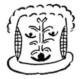

White mask, corn plant in place of nose, red kilt

Navajo Talking God Kachina 139

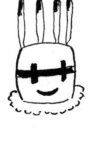

Case or sack mask painted white, with black bands across eyes which are vertical bands. Four feathers upright on head

Chowilawu (Second Mesa) 20

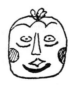

Case mask painted white, built-out nose, red spots on cheeks

White Cloud Clown 259

TABLE 36 MASKS WITH BIRD WINGS ON THE SIDE OF THE HEAD

Green case mask, crow
wings on sides of mask:
 a. Black dress
 b. White wedding dress

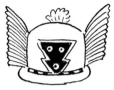

a. Crow Mother 12
b. Crow bride 13

White mask, owl wings
on sides of mask

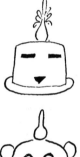

Great Horned Owl
Kachina 78

TABLE 37 MASKS WITH A SINGLE "HORN" OR GOURD
 ON TOP OF HEAD

Green case mask, no
ears, gourd on top of
mask

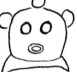

Solstice Kachina 1

Mud colored mask,
gourds on sides and
top of head

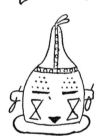

Mud Head Clown 59

Horn on top of head,
cloud symbols under
eyes

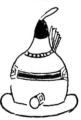

Sotuqnang-u, a deity,
not a Kachina D1

Horn on top of head.
Green mask, black
band across eyes

Zuñi Hemis
Kachina's Uncle 157

TABLE 38 FACE MASKS WITH FEMALE HAIR, DRESS, AND COSTUME

Green mask, maiden whorls, flower in one whorl	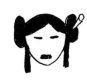	Maswik Mana	116
Green mask, a Hano woman's hairdress	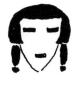	Hano Mana	191
Green mask, Navajo woman's hairdress	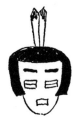	Old Type Navajo Kachina Maiden	136
Green mask, hair in two knots at back of head	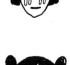	Turtle Kachina Maiden	179
White mask, maiden whorls, white boots, rasp musical instrument		Masao Kachina Mana	124
White mask, maiden whorls, barefooted, carries a yucca whip		Sakwats Mana	184
White mask, maiden whorls, T shaped nose and zigzags under eyes	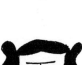	Heheya Mana	35

TABLE 38 Continued

White mask, round eyes, colored rectangles under eyes

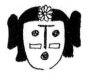

Powamui So-aum 39

Face mask with nose. Triangular areas of cross hachures under the eyes

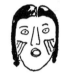

Piptu Wu-uti 252

Face painted blue. Feathers in place of ears

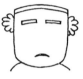

Hano Mana 264

TABLE 39 Masks with a single horn on the side of the head

Green mask, red ear on one side, horn on the other

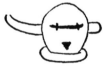

Long-horned Kachina 96

White mask, white ear on one side and horn on the other

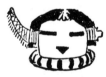

Zuñi Rain Priest Kachina 154

Green mask, horn on one side, a fan-like ear on the other

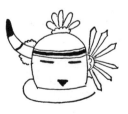

Solstice Kachina (First Mesa in Snake Dance Year) 164

TABLE 40 MASKS WITH TABLETAS

Chin all colors radiating from a point. Man's moccasins, costume made of eagle feathers

Hopi Salako 117

Same as above but with white boots

Hopi Salako Mana 118

White mask, red hachures or red spots on cheeks; woman's white ceremonial costume or black dress

Butterfly Kachina Maiden 120

Mask white on one side, brown on the other

Cumulus Cloud Maiden 98

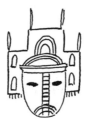

Mask green on one side, pink on the other. Phallic symbols on the tableta

Hemis Kachina 132

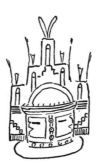

TABLE 40

Mask green on one side,
red on the other, no
phallic symbols on the
tableta;
 a. Corn plant symbols
 b. Butterfly symbols

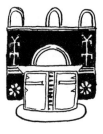

a. Zuñi Jemez
 Kachina 155
b. Butterfly Zuñi
 Jemez Kachina 246

Green mask, tableta with
cloud symbols

A Santo Domingo
Kachina 196

No mask but various
types of tabletas,
woman's dress,
bare feet

Butterfly Maiden,
not a kachina

Headdress with three
half-discs representing
clouds. White mask at
First and Second Mesas;
Third Mesa, no mask.
Feathers hang across face

Cumulus Cloud
Kachina 97

Green case mask.
Tableta with butterfly
painted on it, as well
as corn symbols.
Tube mouth

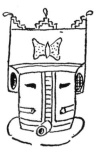

Poli Sio Hemis
Kachina 246

TABLE 41 MASKS WITH RECTANGULAR MOUTH WITHOUT BEARD.
NO HORNS, ETC.

Green mask, white area
about the eyes

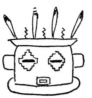

Snow Kachina 99

White mask with black
band across eyes

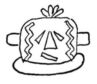

Hututu 175

White mask with red fea-
tures such as vertical zig-
zags, diagonal eyes and
mouth

Heheya's Uncle 36

White mask, black moon
and stars

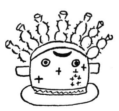

Prickly Pear Cactus
Kachina 220

White mask, mouth of
interlocking half-
squares, ears of corn
painted on sides of mask.
Red kilt

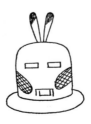

Navaho Talking God
Kachina 139

TABLE 42 MASKS WITH TRIPODS ON TOP OF HEAD

Mask color variable, rec-
tangular eyes,
vertical line in place
of nose

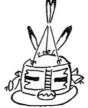

Marao Kachina
(Third Mesa) 170

Green mask, pothook
eyes, snout, yucca leaves
on kilt

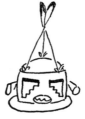

Yucca Skirt
Kachina 172

Mask color variable, rec-
tangular eyes, snout

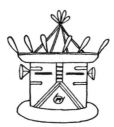

Marao Kachina
(Second Mesa) 170

Case mask, half green
and half red, divided
by a vertical band of
black and white in
center of face. Tube
mouth

Tasaf Kachina 249

TABLE 43 Face masks with horns on side of head

White mask, triangular
mouth, chin segments
of all colors

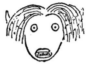

Supai Kachina 143

Black face mask with
snout

Buffalo Kachina
(First Mesa) 93

White mask, mussed up
hair, medium snout

Mad Kachina 198

Bibliography

BUNZEL, RUTH L.
1932 Zuñi Kachinas. B.A.E., 47th An. Rept. 4, p. 837.

COLTON, H. S. AND E. NEQUATEWA
1932 The Ladder Dance. Museum Notes, M.N.A., Vol. 5, p. 5.

DORSEY, G. E. AND H. R. VOTH
1901 The Oraibi Soyal Ceremony. Field Columbian Museum, Pub. 55, Anthrop. Series, Vol. III, No. 1.

EARL, EDWIN AND EDWARD A. KENNARD
1938 Hopi Kachinas. J. J. Augustin, N.Y.C.

FEWKES, J. WALTER
1894 Int. Archiv Fur Ethnographie, Bd. VII
1897 Tusayan Kachinas. B.A.E., 15th An. Rept., Pl. CVIII.
1901 The Lesser New Fire Ceremony at Walpi. Am. Anthrop., Vol. 3, p. 438.
1903 Hopi Kachinas. B.A.E., 21st An. Rept.
1923 Ancestor Worship of the Hopi Indians. Smithsonian An. Rept. 1921, pp. 485-506.

HAWLEY, FLORENCE
1937 Am. Anthrop., Vol. 39, pp. 644-46.

HODGE, GENE MEANY
1938 Kachinas Are Coming. Stellar-Miller Co., Los Angeles.

HOUGH, WALTER
1918 "Hopi Indian Collection" in the U.S. National Museum. Proc. U.S. Nat. Mus. No. 2235, Vol. 54, pp. 235-96, Washington, 1918.

KING, DALE S.
1949 Nalakihu. M.N.A. Bulletin 23.

NEQUATEWA, E.
1948 Museum Notes, M.N.A., Vol. 20, p. 60.

STEPHEN, ALEXANDER M.
1936 Hopi Journal. Edited by Elsie C. Parsons, Columbia Univ. Press, N.Y.C.

STEVENSON, M. C.
1887 The Religious Life of the Zuñi Child. B.A.E., 5th An. Rept., pp. 548-50.
1904 The Zuñi Indians. B.A.E., 23rd An. Rept.

VOTH, H. R.
1901 The Oraibi Powamu Ceremony. Field Columbian Museum, Pub. 61, Anthrop. Series, Vol. III, No. 2.

WALLIS, W. D. AND M. TITIEV
1944 Hopi Notes From Chimopovi. Mich. Acad. Sci. Arts and Letters, Vol. 30.

Index of Kachinas

IN THE INDEX the Hopi and English names of the kachinas are listed alphabetically. The number following the kachina name is not a page reference, but the serial number of the kachina given in Chapter 4. Since the kachina names are often different on each of the three Hopi Mesas, some of these various names are given in the index. Names of the deities described in Chapter 5 are also given, the number being preceded by the letter "D."